Bay City

1900–1940

IN VINTAGE POSTCARDS

Leon Katzinger

ARCADIA

First Printed 2002.
Reprinted 2002.

Published by Arcadia Publishing,
an imprint of Tempus Publishing, Inc.
3047 N. Lincoln Ave., Suite 410
Chicago, IL 60657

Printed in Great Britain.

Library of Congress Catalog Card Number: 2002104366

For all general information contact Arcadia Publishing at:
Telephone 843-853-2070
Fax 843-853-0044
E-Mail sales@arcadiapublishing.com

For customer service and orders:
Toll-Free 1-888-313-2665

Visit us on the internet at http://www.arcadiapublishing.com

Dedication

This book is dedicated to my late parents, Peter and Rica Katzinger and their friend, Bill Kentz and my late Uncle Bill Basselman and Aunt Lil, who always were willing to talk to me about my Bay City postcard collection. It is also dedicated to the many people who still sit around and talk about the cards with me, including Barb Eichhorn, who instilled my love of collecting; her son Pete; Carl and Bev Doan; Marshall Carter; Joe Sauve; Ron Bloomfield (who also helped with historical accuracy); Tom Sullivan—and the many others who have shared their memories with me.

I could not have done it without my wife, Jerry, who looked at every card when I bought it and even read every message. Her endless patience and support along with her initial proofreading skills kept me going. I love you always.

My final thanks go to my sons, Josh and Joe. No father could have better sons.

POSTCARD HISTORY SERIES

Bay City

1900–1940

IN VINTAGE POSTCARDS

Happy 65th Anniversary!!

Have fun reminiscing!!

Love

Jim & Jessie La Combe

6-03

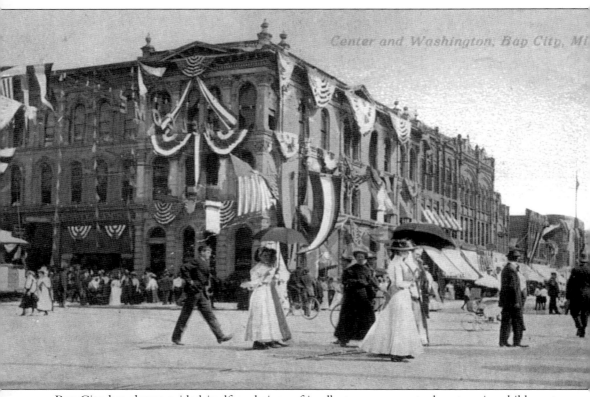

Bay City has always prided itself on being a friendly town—a great place to raise children, to shop, to visit, to work, and to live. While other towns in Michigan have seen their downtown streets filled with boarded up stores, Bay City has managed to maintain a vibrant downtown for 100 years, much like that shown in this *c.* 1908 view. This book is filled with several hundred postcards of Bay City, West Bay City, and the surrounding area. Hopefully, it will bring back memories for some and make new memories for others.

CONTENTS

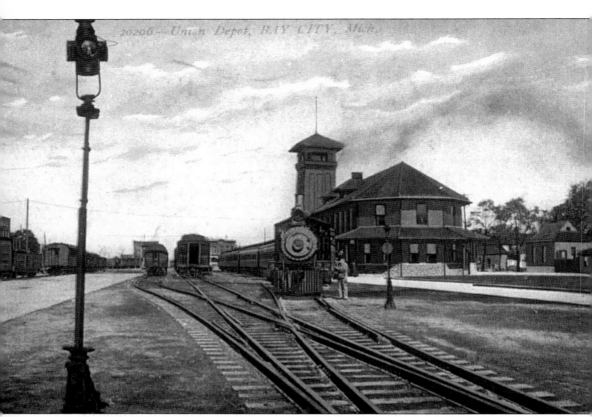

Bay City originated right where all the textbooks said it should be to make great transportation connections. The city's location on the Saginaw River connected it to the Saginaw Bay and the Great Lakes so that we could float logs down to our sawmills, and from there we could ship lumber and finished products all over the country and the world. Three main train companies, like the Pere Marquette in this 1907 postcard, brought their lines to Bay City along with several smaller lines and the Interurban. That brought people to and from Bay City and carried products away. Situated 100 miles north of Detroit, the long summers and good soil make Bay City and the surrounding areas a great place to raise crops and animals and a fine place to sell them. Add in lots of willing workers, good schools, and beautiful churches—and you can see by viewing the postcards an era that has passed into history.

INTRODUCTION

Bay City and West Bay City (which had formed through the consolidation of three smaller cities, Banks, Wenona and Salzburg), joined to form one city, Bay City, in 1905. Both cities shared a history of lumbering, shipping, sugar beet processing, ship building, and as markets for farm products. Their success was based on their prime location at the mouth of the Saginaw Bay with its many ports and close proximity to Michigan's great forests. In 1924, the city's slogan was,"Where the summer trails begin."

County government also was located in Bay City, so many people from surrounding rural communities found their way here. During the era of prime lumbering from 1870 to 1890, Bay City saloons were filled with boisterous lumbermen spending their week's wages right next to lumber mill workers, ship builders, and laborers. It was a rough town in the beginning; but conversely it was and still is a nice place to raise a family.

The Panama Canal was built with cranes from the Bay City Industrial Works. Louis Chevrolet purchased the National Cycle factory, which was renamed Bay City Chevrolet and continued production with most of the same staff that had made bicycles and the Natco truck. Sugar beet processing plants were built, starting at the turn of the century, and flourished along with textile mills that produced quality clothing goods.

Bridges connected the two banks of the Saginaw River, which was lined with saw mills and ship builders, with the largest being the Sage Mill and the Wheeler Shipyard at the turn of the century. (When the Third Street Bridge collapsed in 1975, it rated national coverage.) They evolved from toll bridges to swing bridges to jack-knife bridges.

In order to house Bay City's many visitors, we had the Fraser House, followed by the Wenona Hotel on the same location. Tragically, both were consumed by fire. Lumber barons built huge mansions on Center Avenue on the east side of the river and along Midland Road on the west side. People were concerned that the first high school (on Farragut Street) was built so far out in the country on the east side of town, since the city's earliest growth was right along the Saginaw River. Both sides of the river saw the growth of vibrant downtown commercial districts.

Numerous fire stations dotted the landscape because fires were very common. Bay City was also populated with many movie theaters, churches, and schools—both public and private. Magnificent railroad stations stood on both sides of the river and electric trolley cars took passengers across town and to surrounding communities using the Interurban electric rail cars.

A beautiful City Hall was built in 1896 and was totally refurbished in the 1980s, standing as a tribute to the Bay City of old. Just before the turn of the 20th century, Bay City was the third largest city in Michigan following Detroit and Grand Rapids. Next to City Hall stood the Armory, which played a part in the founding of the Bull Moose Party in 1912 when it broke

away from the Republican Party. That building now houses the Bay County Historical Society.

From the early 1960s on, as a part of urban renewal, beautiful, but inefficient old buildings were torn down and replaced with newer buildings or parking lots. The Bay City Antique Center now occupies the site of the Campbell House, which stood as Rosenbury Furniture for many years. A travel agency is housed in one of our earliest downtown fire stations. The Children's Home was home for many years to the Bay City Board of Education building before it was torn down due to age and the need for parking. The same fate awaited the beautiful Washington Theatre, which still had a working orchestra pit from vaudeville days when it was torn down in 1963.

Farmers from surrounding areas brought their fresh crops to farmers' markets, located in the center of town. Bay City even had its own professional baseball team in the early part of the 20th century, the Wolves, and a harness racing track near the present fairgrounds.

Bay City had its share of floods and fires and other natural disasters along with train wrecks and these were photographed, too. Plank roads connected the town with those to the south and west. Marguerite Sullivan remembers having dinner and taking the Midland Plank Road, which was a toll road, to Auburn where she and her future husband eventually settled and raised their family.

There was also Wenona Beach, an amusement park that drew people from near and far. From 1892 to 1964, people rode the Jack Rabbit roller coaster, the Bullet, the Bumper Cars, the Swing Cars, and many other rides. They played the many arcade games and listened to Nate Doan and Harry Heilman give a "live broadcast" of Detroit Tiger games right from the amusement park. Wenona Beach was also a place where big name comedians and big bands played as a venue between Detroit and Kalamazoo and Jackson. Local companies and schools held yearly picnics at the park. Everyone ate at the Wright Café. No one can remember the Boardwalk or the Swing Ride over the water. A story was shared with the author, in the 1970s by a woman (then in her 80s), that it was much better to ride the open trolley car to Wenona Beach for a dime, than the closed one for 15¢. She said it allowed her to "spoon with her beau," and forced him to put his arm around her.

Enjoy this look back on a town rich in history. These pictures preserve a wonderful heritage of times long passed, which should not be forgotten.

One
WEST BAY CITY

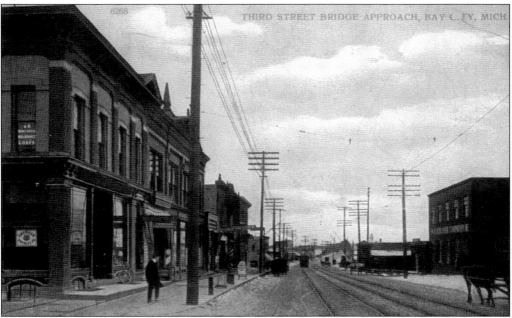

THIRD STREET BRIDGE APPROACH. In the distance, over the Third Street Bridge, is the City of West Bay City, formed when the villages of Wenona, Banks, and Salzburg merged after a series of elections in the three west side communities and in Bay City proper. West Bay City merged with Bay City in 1905.

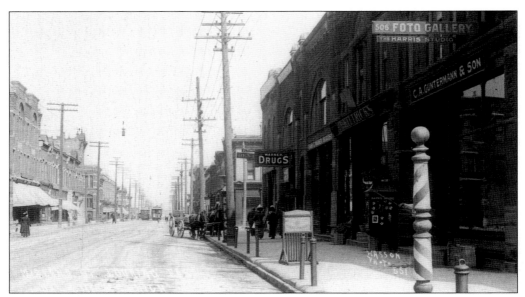

FOTO GALLERY AND WARNER DRUGS. Standing in the heart of the West Bay City business district that ran from Wenona along Midland Street east to the Midland Street Bridge (which was known as the Third Street Bridge on the east side). It is still an active business area today, with numerous pubs that cater to a younger crowd.

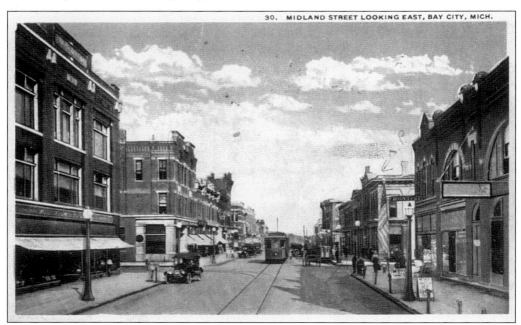

MIDLAND STREET LOOKING EAST. The new automobiles and the old horse-drawn wagon surround the ubiquitous streetcar in the center of this mid-teens card. The George Mosher Hardware was on the northwest corner of Henry and Midland Streets. The Loose Building is on the northeast corner. Loose sold hardware on the first floor, furniture on the second, and coffins on the third. Both buildings still stand, with Bishop Young Furniture in the Mosher Block.

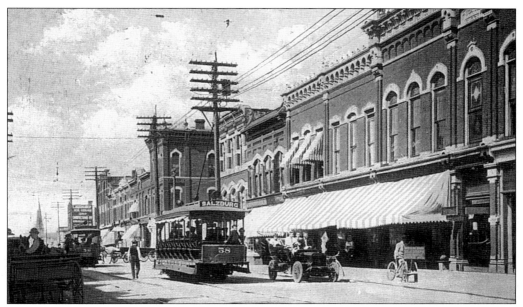

MIDLAND STREET. This picture was taken just after the two Bay Cities had combined in 1905. Note the automobile, the Salzburg Trolley, and the telephone poles. Midland Street (minus the finial work and awnings) looks much like this today. The sidewalks are cement, instead of the wooden ones that were a great concern for West Bay City citizens who were always getting hurt tripping on the wooden sidewalks.

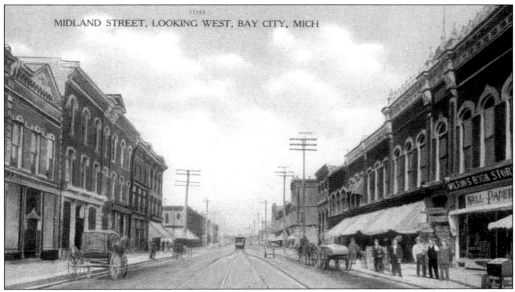

MIDLAND STREET, LOOKING WEST. Trolley cars were a major mode of public transportation in the early days of both Bay Cities. They remained in use into the 1930s and the last tracks were pulled up in the 1950s. Of course, horse-drawn wagons also had a place in history with the last horse-drawn wagon being used by Daniel Feldman, who collected rags by horse cart until the early '50s. The author remembers riding behind his horses and also his barn on North Sherman Street.

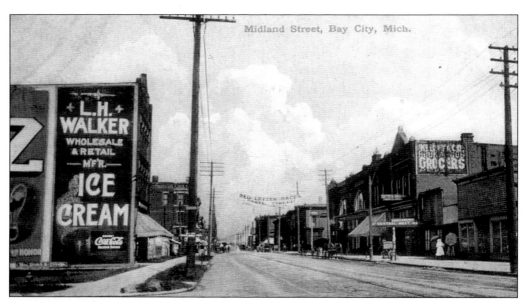

MIDLAND STREET, (L.H. WALKER). Prominent in this postcard are phone lines. West Bay City got phone lines installed after 1878 and had electricity in 1896. The street was made of wooden sections and needed constant repair. With so many wooden structures, fire was a constant concern and both Bay City and West Bay City had many fires in the early years. L.H. Walker was a wholesaler, retailer, and manufacturer of ice cream and confectionery from 1899 on.

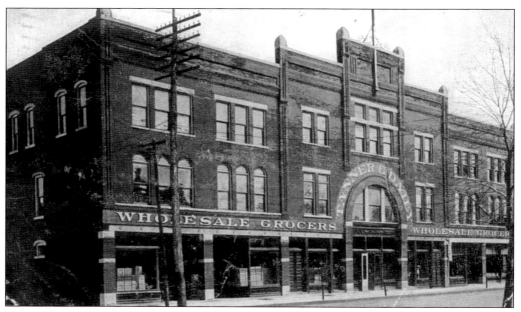

TANNER AND DAILY, FRONT VIEW. Starting as Walsh and Tanner in 1892, Tanner and Daily was one of five wholesale grocers in 1909 that supplied more than 230 retail grocery stores in the area. In the 1960s, the building was used as the materials center for the Bay City Public Schools and even later, as a practice boxing gym. It was torn down soon after the new Liberty Bridge was built to replace the Third Street Bridge, and a pizza parlor was erected near the site.

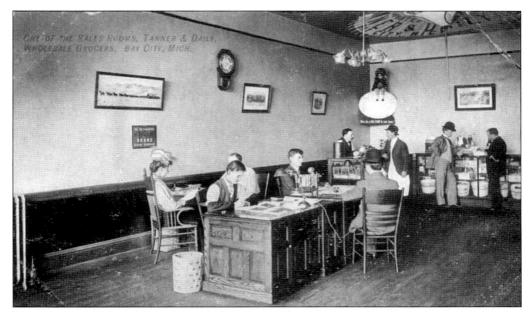

TANNER AND DAILY, SALES ROOM. This is a rare interior view of a wholesale grocer, showing the wooden floor and office furniture. The Tanner and Daily name was even on the ceiling. Their sales rooms took up the entire front of the building. Imagine going shopping and buying items by the bushel basket. (Isn't that a lot like shopping at Sam's Club today?)

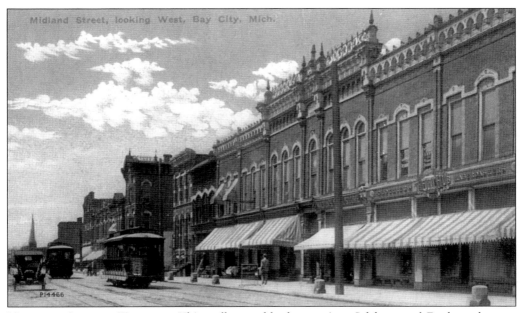

MIDLAND STREET, TROLLEY. This trolley could take you into Salzburg and Banks and across the Saginaw River to the east side. This long block was named and owned by Spencer O. Fisher, who was a prominent lumberman, banker, politician, and one of the owners of Wenona Beach Amusement Park. The building just behind the trolley had a furniture store on the first floor and sold coffins on the third.

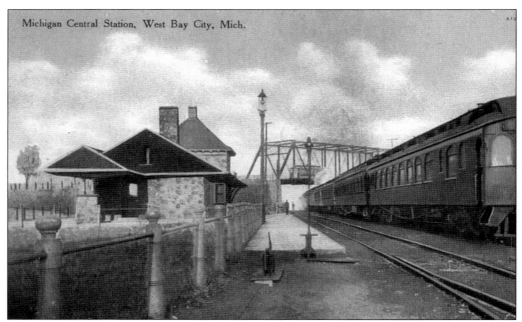

Michigan Central Station, West Bay City, Mich.

MICHIGAN CENTRAL STATION. West Bay City had many rail lines and this depot was one of two located near major train yards. The station was located just west of the Saginaw River and the viaduct carried cars over the tracks. That bridge-like one in the photo was replaced by a cement structure in the 1920s, which came down in 2000 for an at-grade crossing.

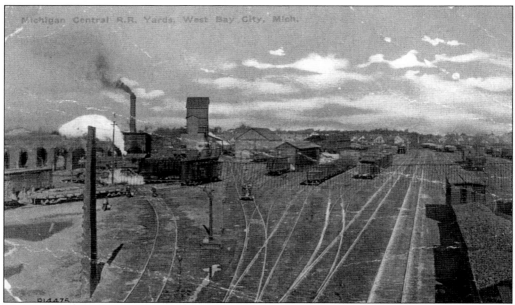

Michigan Central R.R. Yards, West Bay City, Mich.

MICHIGAN CENTRAL RAILROAD YARDS. The MCRR yard was located by the depot in the previous picture. It was connected to East Bay City by a bridge over the Saginaw River, carrying coal, lumber, and many of the products that made Bay City the third largest city in Michigan (behind Detroit and Grand Rapids) just before the turn of the 20th century.

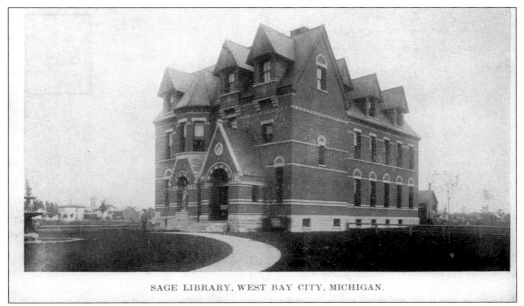

SAGE LIBRARY, WEST BAY CITY, MICHIGAN.

SAGE LIBRARY. Henry Sage was a lumber magnate who lived in New York. He owned one of the two largest lumber mills in the city and many other related industries. He also owned the homes his workers lived in and the stores where they shopped. He donated $50,000 and the land for Sage Library, which opened in 1884. Still in use today, Sage Library is surrounded by large trees and has the fountain, *Leda and the Swan*, in its front courtyard and a statue of a World War I soldier just to the east.

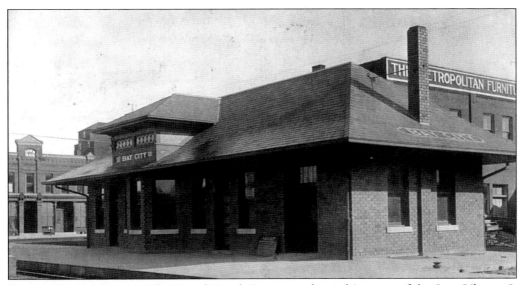

GRAND TRUNK DEPOT. The Grand Trunk Depot was located just east of the Sage Library. It was one of the smallest passenger depots, but survived until 1980 when it was torn down for a parking lot. The Grand Trunk was a stop from Durand to Saginaw, Bay City, and the Upper Peninsula. In all of the depot's history, it never had running water. In its last years, it was an antique shop and many local citizens were sorry it could not be saved.

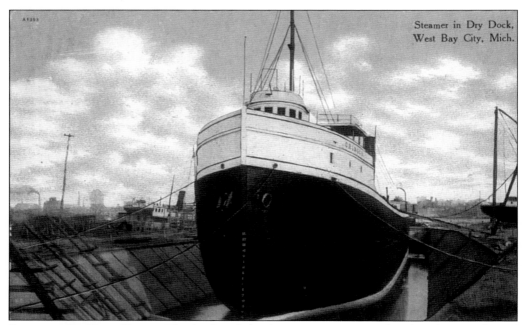

Steamer in Dry Dock,
West Bay City, Mich.

STEAMER IN DRY DOCK. The banks of the Saginaw River were lined with sawmills and shipyards at the century's turn. The Frank W. Wheeler and Co. Shipyard employed hundreds of men. The yard included a steel shop, planning mill, jig mill, and lumber storage buildings. It was located in the center of the Banks neighborhood, at the foot of Joseph Street.

WEST BAY CITY HOSPITAL. This postcard is labeled "the Bay City Hospital" because it was produced after the two Bay Cities had merged. The West Side hospital was located at 903 E. Indiana to serve the medical needs of westsiders while eastsiders had Mercy, the Lutheran Hospital in the South End, Samaritan, and later General Hospital, now the site of Bay Medical.

Two
SAGINAW RIVER

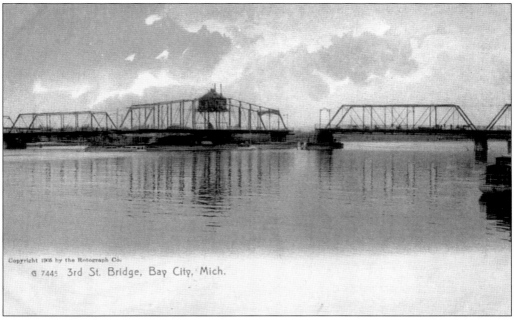

Copyright 1906 by the Rotograph Co.
G 7445 3rd St. Bridge, Bay City, Mich.

THIRD STREET BRIDGE. This bridge, a toll bridge until 1885 when Bay City bought it, was built in 1876 and was a "swing bridge." Although the bridge tender frowned on it, many of us spent lots of time on the open span as ships passed. It collapsed into the river in 1975 and was replaced by the Liberty Bridge just slightly north of it. This bridge was the main connection between the two Bay Cities.

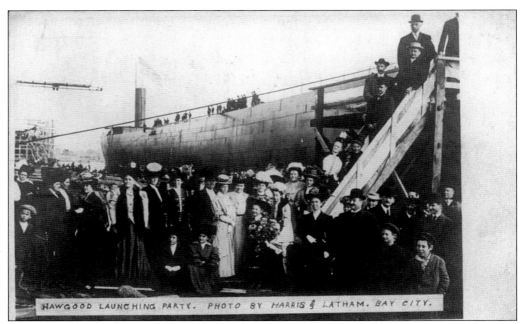

HAWGOOD LAUNCHING PARTY. PHOTO BY HARRIS & LATHAM. BAY CITY.

HAWGOOD LAUNCHING PARTY. Ship launching was a big occasion, as seen with these men, women, and children dressed in their Sunday best. The 549-foot long, steel-hulled *Arthur C. Hawgood* was launched by the West Bay City Shipbuilding Company (the former Wheeler Shipyard) in 1907. The ship's final name was the *George Steinbrenner* and it was sold for scrap in 1979.

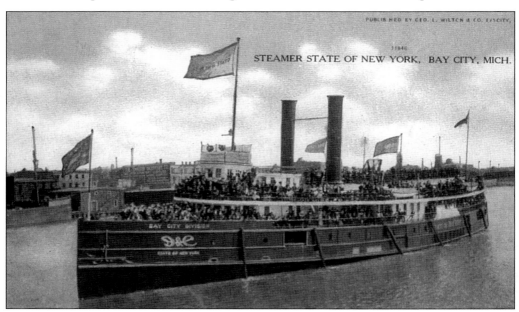

STEAMER STATE OF NEW YORK, BAY CITY, MICH.

STEAMER, *STATE OF NEW YORK*. Many excursion boats traveled on the Saginaw River and Bay in the late 1800s and early 1900s. The *State of New York* was built in Detroit in 1883 and often stopped in Bay City. Over the years her name changed from *The City of Mackinac* to *State of New York* to the *Florida*. In 1936, she became a clubhouse in Chicago.

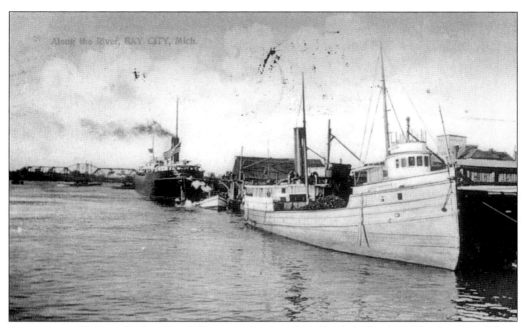

ALONG THE RIVER. Coal and wood-powered steam ships lined the banks of the Saginaw River. People had long waits while the bridges opened for boat traffic—just like today. Tugboats were used to help the larger ships that navigated the Saginaw Bay. Always a danger to the ships were the numerous logs floated to the many Bay City saw mills.

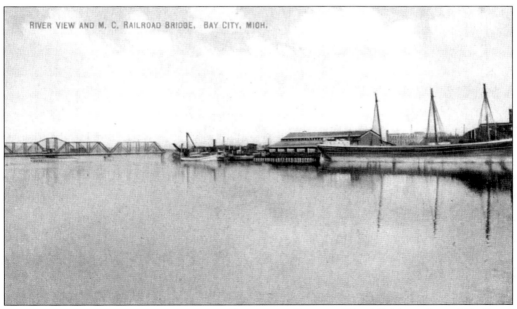

RIVER VIEW AND MICHIGAN CENTRAL RAILROAD BRIDGE. The Michigan Central Railroad Bridge connected the many rail lines on both sides of the Saginaw River. It was also a popular, if illegal, swimming spot for the young men who dared to ignore the commands of the watchmen. The Saginaw River was relatively clean 100 years ago.

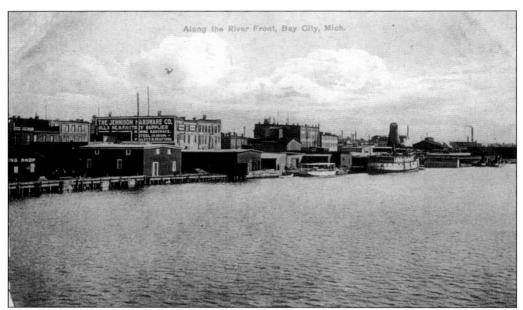

ALONG THE RIVER FRONT. No portion of the Saginaw River went unused on either side of the two Bay Cities near the downtown areas. This view shows docks and many storage buildings for the loading and unloading of cargo. The river was wide enough and the shoreline high enough that flooding was not a problem in this part of town.

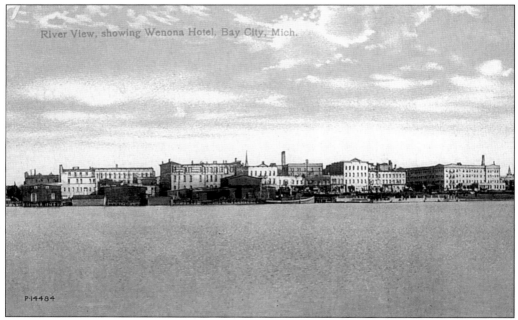

RIVER VIEW, SHOWING WENONAH HOTEL. Taken from the west side, this postcard shows the Wenona Hotel on the right and, just to the left of it, the building that once housed Herman Hiss Jewelers, which is now the home of the Mill End Store. Many century-old buildings along Water Street remain standing today.

United States Tires.
Weed Tire Chains.

Gentlemen:

Our MR. A. C. GIBBONS

will call on you on or about

May 15th

He will be pleased to receive any orders you may have in our line.

Yours respectfully,

THE JENNISON HARDWARE CO.

901-903-905-907-909 Water St. BAY CITY, MICH.

JENNISON HARDWARE. A Mr. Gibbons mailed this advertising card to Lapeer, Michigan, in 1917. I wonder if he realized that Jennison Hardware would have five more stories added, that the Bay County Historical Society would store many artifacts there, or that it would end up being used as Studio 23 (an art studio) and condominiums near the river.

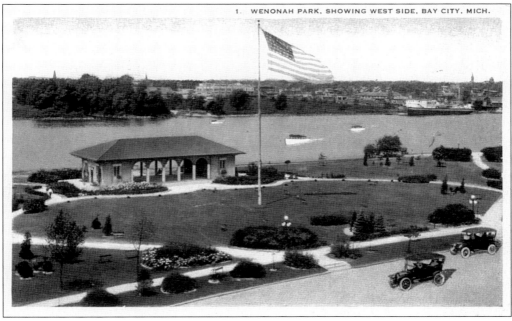

1. WENONAH PARK, SHOWING WEST SIDE, BAY CITY, MICH.

WENONAH PARK, SHOWING WEST SIDE. This combination picnic area/bathroom building stood for many years where the Friendship Shell is now located. Picnickers could have a meal and enjoy the boat traffic. The Sage Lumber Mill and Beutel Packing Company were directly across the river—today's Veteran's Memorial Park.

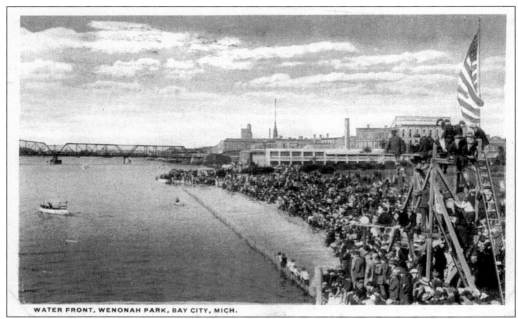

WATER FRONT, WENONAH PARK, BAY CITY, MICH.

WATER FRONT, WENONAH PARK. Spectators lined the riverfront in 1918 much as they do today. In the 1930s, there was a public pool located here and an annual Water Carnival was held with parades along Center Avenue led by celebrities like Buster Crabbe (of Flash Gordon fame). The fishing was good, too.

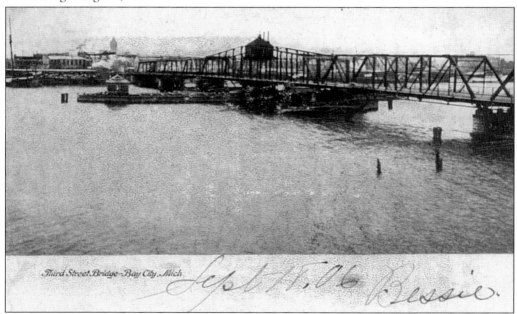

Third Street Bridge–Bay City, Mich.

THIRD STREET BRIDGE. Since the Third Street Bridge was a swing bridge (unlike today's jackknife bridges), the bridge tender could sit in his shack in the center of the bridge or in one out over the water. This 1906 view shows a little of West Bay City in the background. Since it was a toll bridge until 1883, tolls varied from 3¢ to 6¢, depending on if you were walking or had horses.

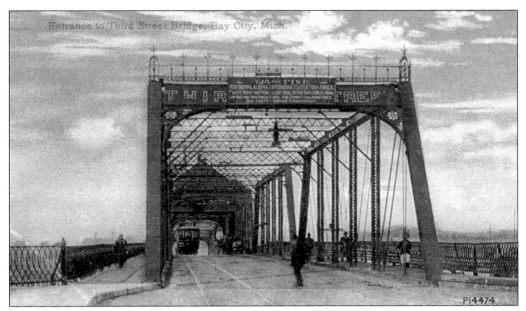

ENTRANCE TO THIRD STREET BRIDGE. The sign on the Third Street Bridge warns of a $25 fine for "driving across this bridge faster than a walk." When it collapsed in 1975, many people bought tables made from its oak and other specialty items made from its wrought iron. They all came with a special nameplate designating the items as an "official Third Street Bridge" item.

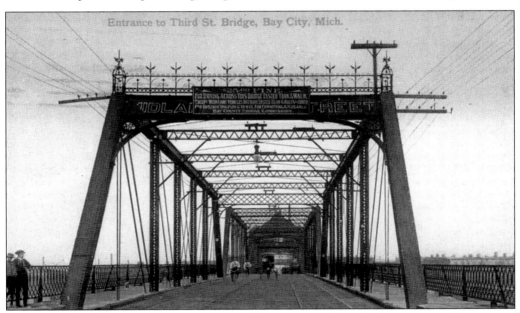

ENTRANCE TO MIDLAND STREET BRIDGE. Although this picture looks very much like the one on the opposite page, if you look closely at the top, you will see that it says "Midland Street." When the Third Street Bridge fell in, the pupils at my school, Dorland Elementary (an elementary school on the west side), did not know where it was located. When told the Midland Street Bridge had fallen in, they knew right away.

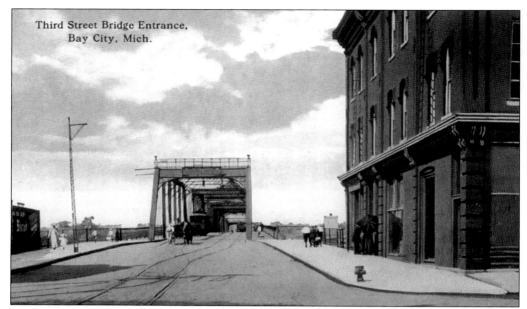

Third Street Bridge Entrance,
Bay City, Mich.

THIRD STREET BRIDGE ENTRANCE. The building on the approach to the Third Street Bridge has been the home of St. Laurent Brothers since 1904. Being in an especially rough part of town back then, it was rumored there was a trap door that dropped undesirable lumberjacks into the Saginaw River. Today, St Laurents' still does a large candy business, with siding covering the brickwork on the building that was built in 1865.

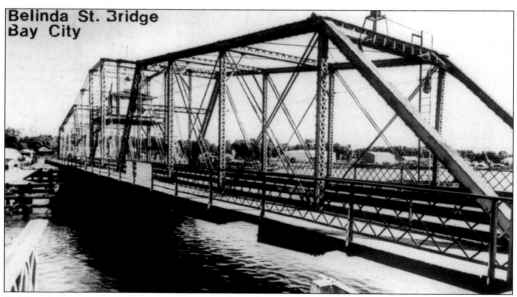

Belinda St. Bridge
Bay City

BELINDA STREET BRIDGE. The date on this postcard is 1978, but it is a rare view of the Belinda Street Bridge, which seems to have no older views. Slightly newer than the Third Street Bridge, the Belinda Bridge suffered from age and from being struck by a passing freighter. Near the end of the bridge's life, it had to have constant running water on the road surface to stop its joints from expanding. The bridge was located just west of the present Independence Bridge.

FLOODING ALONG RIVER. Floods were a constant problem in low-lying areas, especially in the spring after heavy snow. People who lived in the lowlands often found themselves stranded with the only way in or out by boat. This picture was taken about 1907.

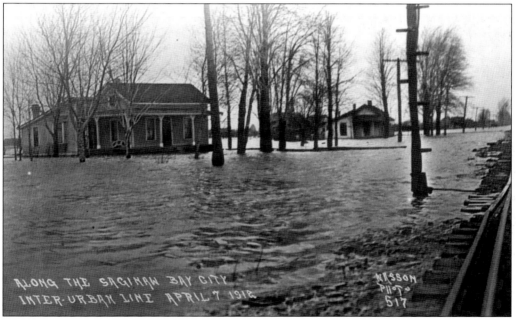

ALONG THE SAGINAW BAY CITY INTER-URBAN LINE. The flood of April 7, 1912, was an especially bad one. These homes were several hundred feet from the Saginaw River and still were surrounded by floodwaters. The Inter-Urban lines connected Bay City with Saginaw and other surrounding communities.

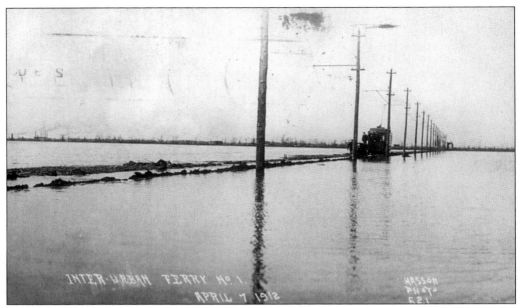

INTER-URBAN FERRY NO. 1. Wasson was one of several local photographers who chronicled the day-to-day happenings in Bay City. You can see that the Inter-Urban train was not a large one. Inter-Urbans were much like streetcars and buses, stopping for passengers at the corner. This picture was taken close to the spot where an Inter-Urban crashed into the river, with seven lives lost including a mother and her three small children.

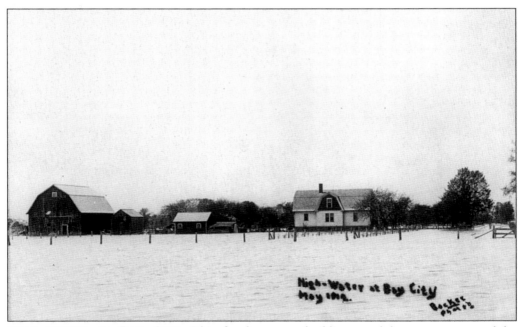

HIGH WATER IN BAY CITY. This farmhouse, outbuildings, and barn were covered by floodwater in 1912. The waters caused damage, but they also allow the land along the river to be some of the most fertile and productive. Crops included corn, wheat, hay, and sugar beets.

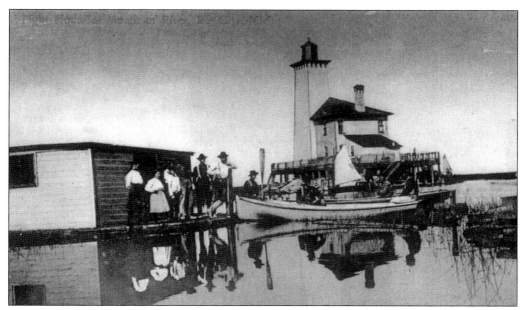

LIGHTHOUSE AT MOUTH OF RIVER. With all the shipping that went up and down the Saginaw River, this lighthouse served an important function. Initially, funds for the lighthouse came from shippers. The light tender and his family spent long days and weeks tending the light, making sure that it was shining in all types of weather. There were many years when the lighthouse keeper was a woman.

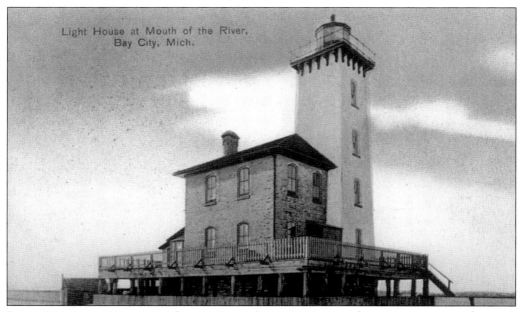

LIGHT HOUSE AT MOUTH OF RIVER (LAND SIDE). Having stood on private property for many years, this lighthouse has stood empty since channel markers replaced it in the 1950s. However, with a recent change in property ownership, it is scheduled to be refurbished and may once again regain its stately look of old.

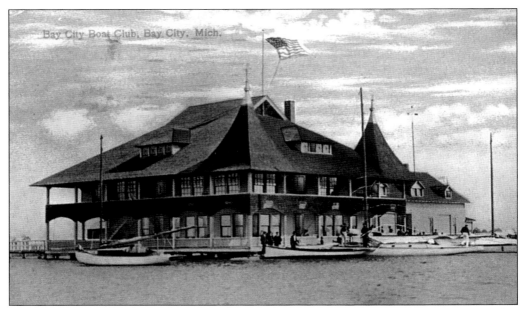

BAY CITY BOAT CLUB. Standing at the foot of Pine Street in Essexville, the Bay City Boat Club was a private club with members from the more affluent set. The building was large enough to house parties and many new boats were launched from its premises. A smaller club very near the same location replaced it.

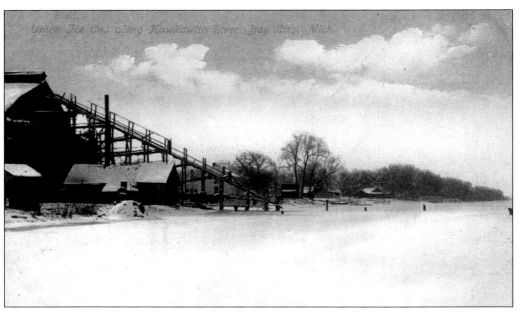

UNION ICE CO. Before electricity, and before everyone had a refrigerator, iceboxes were used to keep perishable items cold. Chunks of ice were sawed from the Kawkawlin River and Lake Huron and stored in sawdust in Union Ice buildings around town. Amazingly, they lasted through the summer and were delivered to homes by horse drawn carts. A sign in your window let the iceman know what size ice block you needed.

28

Three
INDUSTRY/MINING

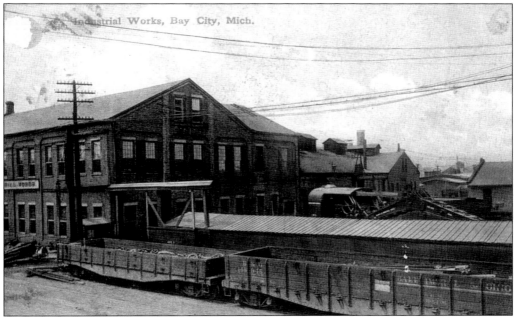

INDUSTRIAL WORKS. This company made cranes for unloading grain from ships, loading iron ore onto ships, and up-righting trains that had derailed. They also made jackhammers. IW Cranes handled 85 percent of the structural steel for the building of the Panama Canal. It was later called Industrial Brownhoist and finally, American Hoist before it went out of business. The main office was designed by Detroit architect, Albert Kahn.

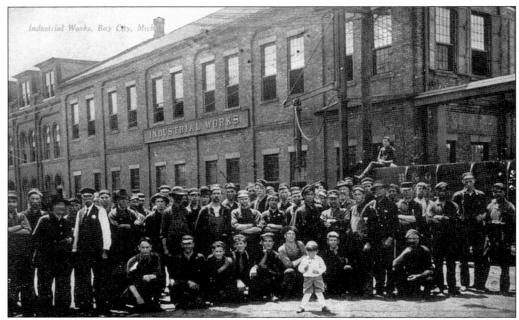

INDUSTRIAL WORKS (WORKERS). William L. Clements, owner of the Industrial Works, was one of the biggest employers in the community. He was a man of great wealth and amassed a very large collection of rare books and papers. Among his possessions was a Guttenberg Bible. Much of his fine collection is housed at the William Clements Library at the University of Michigan.

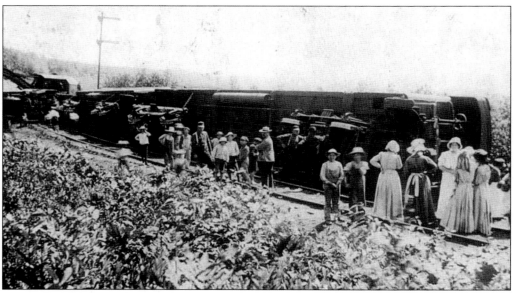

INDUSTRIAL WORKS (CRANE AND TRAIN WRECK). Founded in 1873, the Industrial Works came into being just as the Industrial Revolution was taking off. Their lifting capacities quickly grew from 20 tons to 200 tons in 1922. The wrecking crane in the background was a hoisting device capable of self-propulsion. All parts of the cranes were designed and built on the site of the IW.

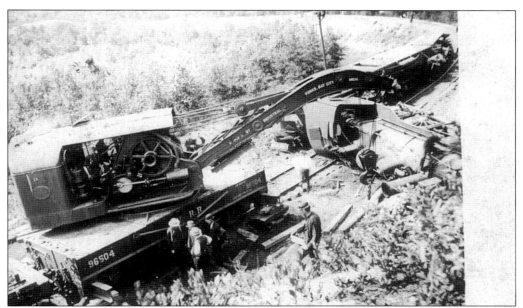

INDUSTRIAL WORKS (CRANE). Industrial Works locomotive cranes were capable of lifting various loads by hook, bucket, or magnet, of swinging these loads 360 degrees around the machine itself, and propelling these loads on rails. No train wreck was too difficult for an IW crane to upright and remove. The French, in World War I, also used IW cranes. The final successor, American Hoist, closed the Bay City division in 1983.

INDUSTRIAL WORKS MAIN OFFICE. The brains of the IW, it was placed at the threshold of the plant. It housed the executive and financial offices along with the purchasing, sales-engineering, and service departments. Built in 1910, the 20 domestic and 6 international IW offices were also directed from here. The offices were refurbished and used to house an E.P.A. super computer until a few years ago.

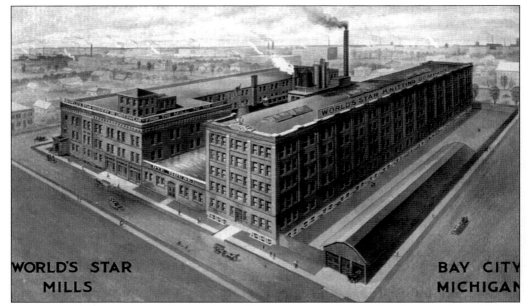

WORLD'S STAR
MILLS

BAY CITY
MICHIGAN

WORLD'S STAR MILLING. "From the Mill to the Home" was the slogan of World Star. Incorporated in the early 1890s, the mill made all types of high-grade hosiery and underwear for men, women, and children. All items were sold with a 100 percent guarantee. In 1908, the company was pleased to offer their employees a factory that was state of the art. It was built of concrete, brick, and glass and contained every known appliance that would increase the efficiency and add to the health and comfort of employees.

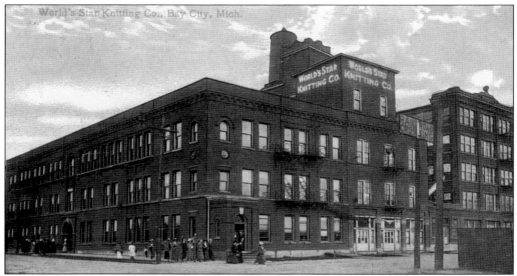

WORLD'S STAR KNITTING CO. Products varied according to the seasons with "Sportsmen's Special Stockings" being a fall and winter item and " Ladies Umbrella Knee Union Suits" being offered in the spring/summer catalogue. All World Star items were sold directly to consumer by mail order or through local salesmen. Business was so good that a plant was erected in 1912, as shown in this postcard. Bay City's first radio station was WSKC, for World's Star Knitting Co.

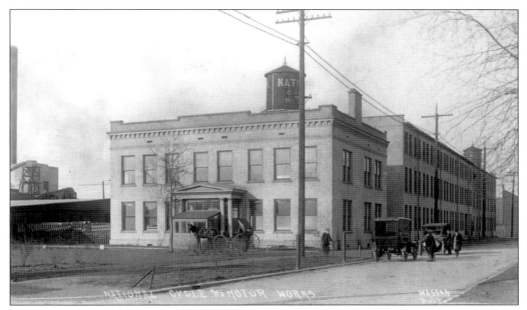

NATIONAL CYCLE. National Cycle was incorporated in 1892 and made bicycles until 1915. Its slogan was, "A National Rider Never Changes His Mount." In 1900, prices ranged from $40 for a Regular Road Model to $65 for a Chainless. Tandems and Thirty Inch Wheel models were available by special order and many special accessories such as saddlebags, gears, and custom paints were available by special order. (Courtesy of Tom Sullivan.)

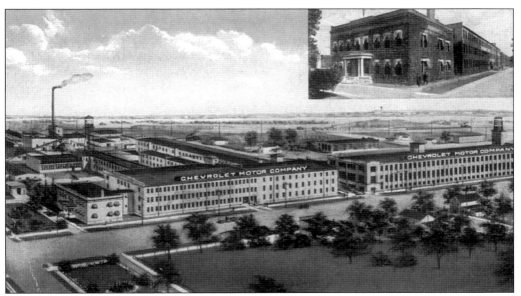

CHEVROLET MOTOR CO. In 1916, William Durant came to Bay City and was impressed with the quality of the National Cycles and the short-lived Natco Truck (of which less than 25 were built in 1913). He purchased the plant and made it into a Chevrolet Motor Plant. When my Uncle Bill started working there in the 1930s, many National Cycle workers were still on the payroll. The last sections of the original plant were torn down in the late 1920s.

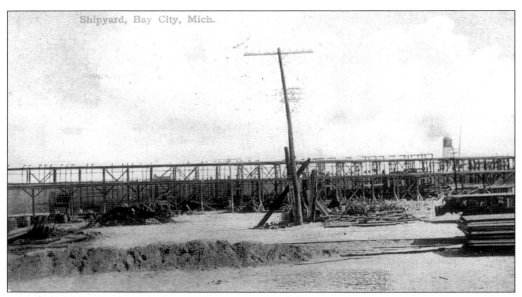

SHIPYARD. Shipyards over the years included the F.W. Wheeler and Co. of West Bay City (which closed about 1905), the Davidson Shipbuilding Co. (whose one remaining dry dock is near the Community Center), and the Defoe Shipbuilding Co. Defoe moved several times before ending up where Hirschfield's Scrapyard is now located. Defoe was founded by a former elementary school principal in 1905 and pioneered the "roll-over" method of launching, early in World War II.

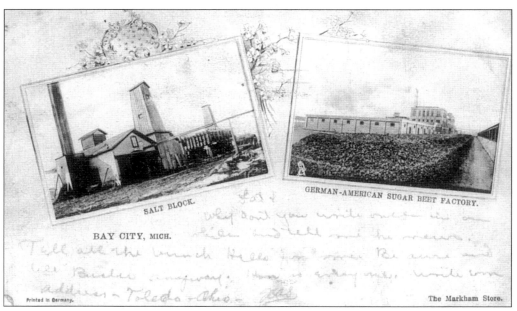

SALT BLOCK.

BAY CITY, MICH.

GERMAN-AMERICAN SUGAR BEET FACTORY.

Printed in Germany.

The Markham Store.

SALT BLOCK AND GERMAN-AMERICAN SUGAR BEET FACTORY. This double postcard shows a salt block and sugar beet factory—two early endeavors. While Dow Chemical was 20 miles to the west with its brine wells, Bay City had its own share of salt mines. It was also one of the first areas in the state to have successful sugar beet factories, which are still going strong today.

34

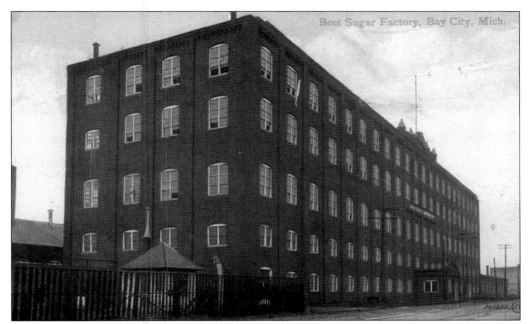

BEET SUGAR FACTORY. Because processing sugar beets required a lot of water, the Saginaw River had several plants located nearby. At the turn of the century, Michigan farmers were paid a bounty to grow sugar beets, which were able to compete with cane sugar. Even so, factories came and went because it was difficult to make money on sugar beets in a consistent fashion.

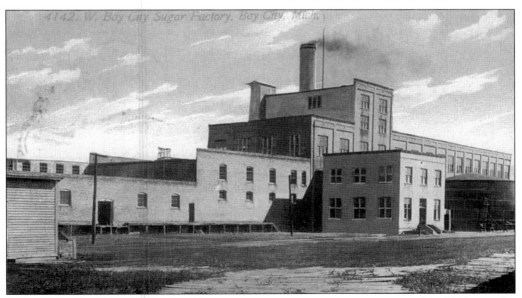

WEST BAY CITY SUGAR FACTORY. The West Bay City Sugar Factory opened in 1900 near the west end of the Belinda Street Bridge. Portions of the building remain today and are a part of the Surath Scrap Yard. The West Bay City factory gave fine competition to the Michigan Sugar Plant across the river in Essexville and the German-American plant (later Monitor Sugar) in Salzburg. Only Monitor survives today.

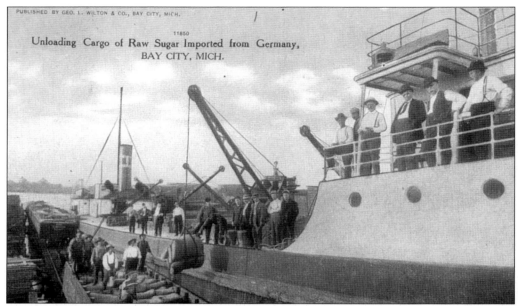

PUBLISHED BY GEO. L. WILTON & CO., BAY CITY, MICH.

11850

Unloading Cargo of Raw Sugar Imported from Germany,
BAY CITY, MICH.

UNLOADING CARGO OF RAW SUGAR. Dated 1908, this postcard shows that local farmers could not provide enough raw sugar beets for the local factories. Preserving the piles of sugar depended on many factors, with weather being crucial. If the winter was too warm, the beets would rot before they could be processed. If the fall was too rainy, farmers couldn't get the beets from the fields to the factories.

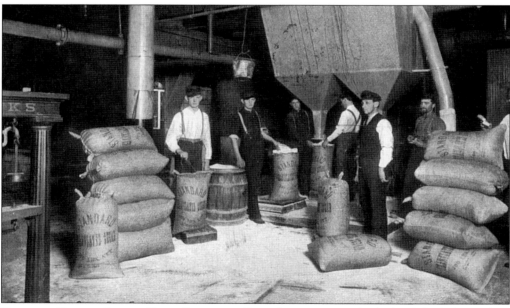

PACKING ROOM, SUGAR BEET FACTORY. Sugar beets were washed, sliced, boiled, purified, and concentrated. The finished sugar was shipped in 100-pound bags. Getting the beets to the factories and then getting the final products to the ships and rail lines was an astounding feat considering the main manner of conveyance was via horse and wagon.

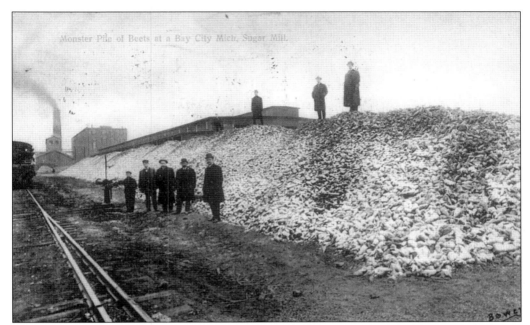

MONSTER PILE OF BEETS. The person who mailed this postcard in 1909 was actually working at this plant. According to Tom Mahar, author of *Sweet Energy*, these piles could be a 1,000 feet long and from 18 to 20 feet high. Tom also says the beets changed from day to day and even hour-to-hour. Michigan went from a high of 23 sugar beet plants down to the present 3.

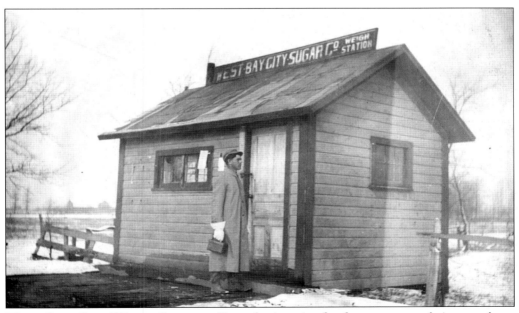

WEST BAY CITY WEIGH STATION. To make it easier for farmers to get their sugar beets weighed, small weigh stations were located in more convenient locations. This one, belonging to the West Bay City Sugar Company, was not much larger than a small shack. These weigh stations saved the farmer time since beet harvesting was so dependent on weather conditions.

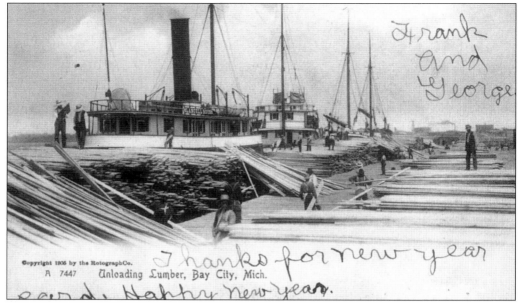

Frank and George

Thanks for new year card. Happy new year.

UNLOADING LUMBER. Lumbering was one of the first and greatest industries in Bay City, with peak years from 1860 to 1890 for Michigan logs. Even after the woods were logged out, many factories continued to make finished items from lumber—even if it had to be shipped in. This 1905 postcard shows lumber being brought in. The wood was used to make pails, barrel hoops, barrels, window frames, wooden pipe, siding, and hardwood flooring.

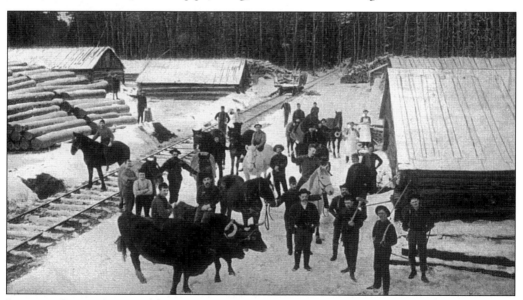

LUMBER CAMP. Oxen and horses provided much of the pulling power in lumber camps. The value of the lumber taken from Michigan forests was probably greater than that of all the gold taken from California. One report said that there was enough lumber cut in Bay City mills in the peak year of 1888 to build a sidewalk of two-inch planks four feet wide circling the globe four times!

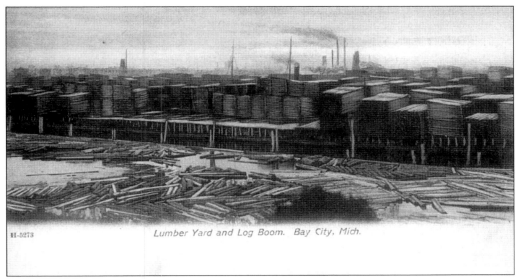

H-5273 *Lumber Yard and Log Boom. Bay City, Mich.*

LUMBER YARD AND LOG BOOM. A large boom at the riverbank lifted the logs to the saws, usually on a second floor. A sawyer determined where the log would be cut. A tramway carried the finished lumber to the yard where it was placed in piles like this and left to age. The lumber was piled high as 25 feet and allowed to cure. The stacking process helped protect the lumber from the elements.

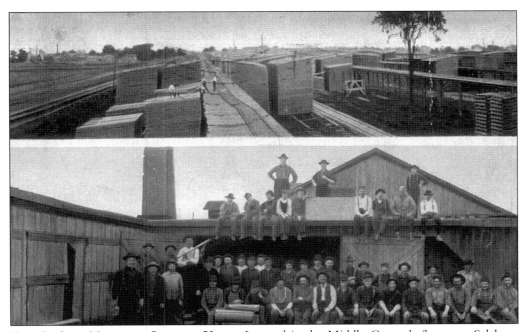

KERN'S SAW MILL AND LUMBER YARD. Located in the Middle Grounds (between Salzburg and the south end of town) at the west end of the long gone Cass Avenue Bridge, the Kern Saw Mill and Lumber Yard was one of 23 lumber mills listed in the 1909 R.L. Polk and Co. Directory. They were one of nine mills that specialized in hardwood lumber and the production of hardwood flooring.

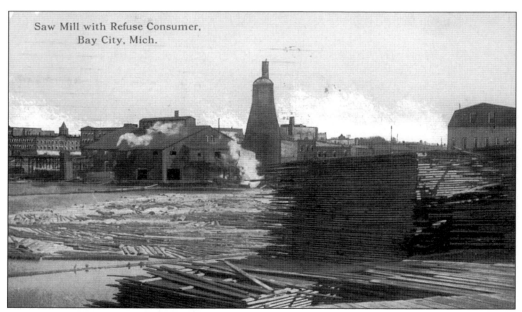

Saw Mill with Refuse Consumer, Bay City, Mich.

SAW MILL WITH REFUSE CONSUMER. Not all parts of the log were usable. Some of the parts were used as firewood. Other parts were burned in the refuse burner. Before they were burned, they were slashed into bits by machines called "slashers." The refuse burners were the cause of many saw mill fires. These fires often spread to nearby residential and commercial areas with 42 fires striking the city, at a cost of more than $10,000 each losses between 1895 and 1918.

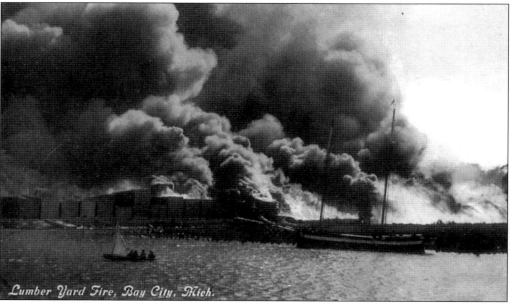

Lumber Yard Fire, Bay City, Mich.

LUMBER YARD FIRE. Wooden pipes were used all over the country by cities and industries. This postcard shows the Michigan Pipe Company engulfed in flames. It was located just west of the Chevrolet plant on Madison Avenue. This particular fire occurred in 1906, but the factory was plagued by fires before that date and afterwards, too. They made wooden pipes until 1956.

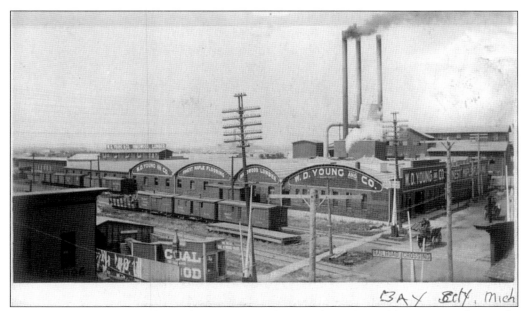

W.D. YOUNG AND CO. The Walter D. Young plant was located in Salzburg. It was famous for its hardwood floors and wooden pails. The plant included offices, flooring mills, warehouses, drying rooms, lumberyards, kilns, sawmills, boiler room, steam engines, stables, refuse burner and a blacksmith shop. W.D. Young was also involved with the German-American Sugar Company, serving on the board and as president from 1914 to his death in 1916.

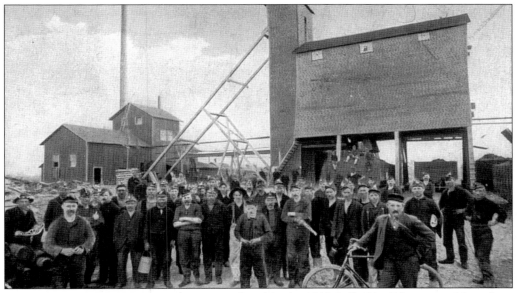

CENTRAL COAL MINE. Ten coal mines are listed in the 1909 Polk City Directory with perhaps as many as 25 in operation. The coal was bituminous and mining was a difficult job, but there was a lot of coal under the ground. The Central Coal Mine was also known as the Salzburg Mine. There are still slag piles from many of the mines visible today. Note the cycle in the foreground. Is it a National?

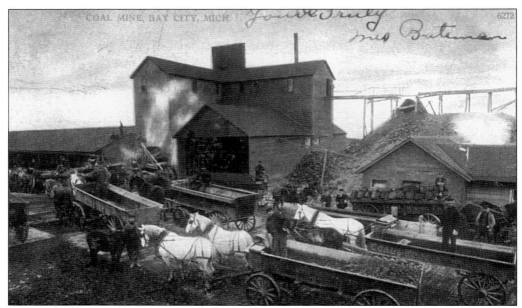

COAL MINE. As with lumbering and sugar beets, horses were the primary way that coal was moved once it was mined. Many coal deposits were discovered when drilling for salt in earlier years. As lumber ran out, people turned to coal for industrial use and home heating. Most coal was mined at less than 200 feet below the surface and most mines suffered problems of flooding due to the nearness of the Saginaw River.

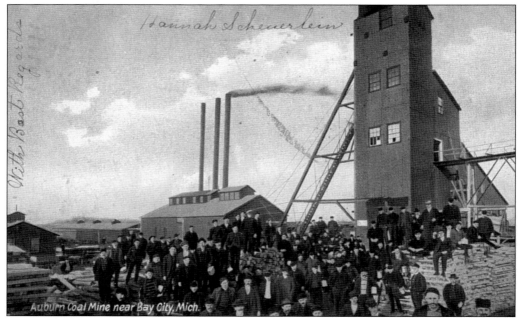

AUBURN COAL MINE. Located in Williams Township, this mine, too, had lower-grade coal that sold at lower cost but was expensive to remove from the mine. There are still slag piles remaining along the I-75 expressway that are remnants of Auburn's mining days.

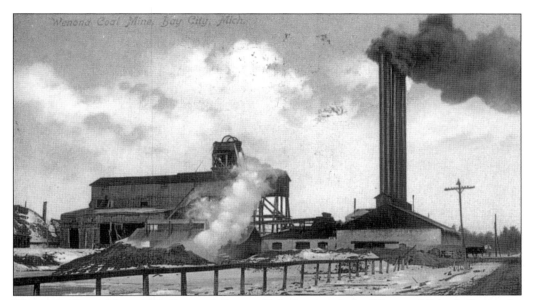

WENONA COAL MINE. E.B. Foss and George G. Jackson sunk the Wenona Mine shaft near the mouth of the Kawkawlin River and it turned out to be one of the richest in the county. Now it is just a memory, like the Monitor, Handy Brothers, United City, What Cheer, and all of the long forgotten mines of Bay City and Bay County.

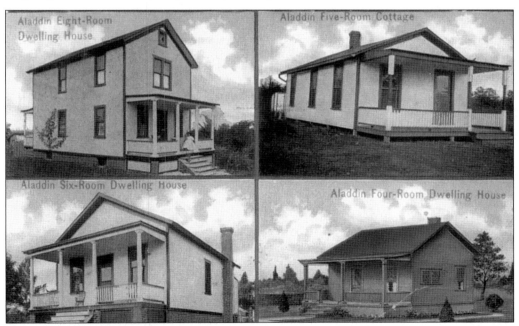

FOUR ALADDIN HOMES. The North American Construction Company produced "redi-cut" houses that went by various names through the years. They included Aladdin Houses, Aladdin Homes and finally, just Aladdin. Aladdin was one of three ready-to-build home kit manufacturers in Bay City. The other two were Liberty Homes and Sterling Homes. Sears tried to compete for a while, but never was as big as Bay City's three companies.

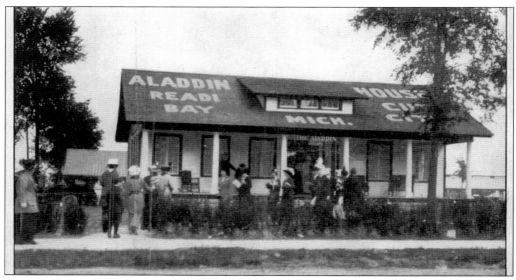

ALADDIN REDI-CUT HOUSES. William and Otto Sovereign pioneered Aladdin's prefabricated homes. The back of this Aladdin card states, "You can be living in one of these pretty Aladdin bungalows within four weeks after placing your order. You can build it yourself or superintend its erection and save at least one-third the ordinary cost of building. Send a postcard today for our large 1915 catalogue, in colors—over 100 different styles…"

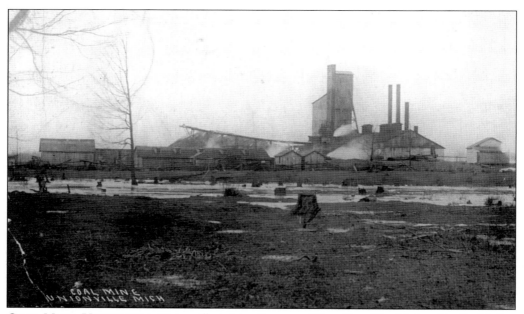

COAL MINE, UNIONVILLE. Unionville is 14 miles east of Bay City. The Unionville Coal Mine stood five miles west of Unionville and the slag pile was one of the tallest such structures in Michigan. It was located on a bend on M-25. I know, because I lived right across the street as a young child and always looked forward to seeing the Michigan "mountain."

Four
WASHINGTON
AVENUE

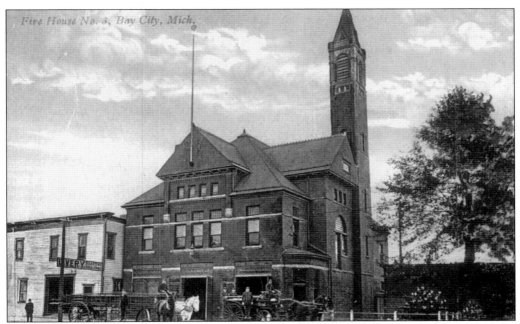

FIRE HOUSE #3. This large hose station was in the center of town. It was one of ten stations in 1908 that included hose carts, steam fire engines, hook and ladder trucks, and a chemical truck. The tall tower was for drying hoses. The McKinley and Adams station, erected in 1912, replaced Fire House #3. The building later housed Clark Sporting Goods and later yet, it was a "junk shop" near the corner of Washington and Columbus Avenues.

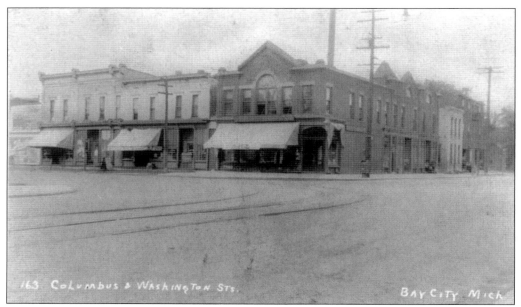

163. COLUMBUS & WASHINGTON STS. BAY CITY MICH.

COLUMBUS AND WASHINGTON. The intersection of Washington and Columbus was one with prominent businesses on every corner and Fire House #3 just across the street. Josephus F. Martin had a drugstore on the northeast corner of the intersection that specialized in "Perfumes and Toilet Articles, with Prescriptions a Specialty." His slogan was, "Our drugs are pure, and prices right." Breens, a long-time bicycle shop and Edison Phonograph dealer was across Columbus Avenue.

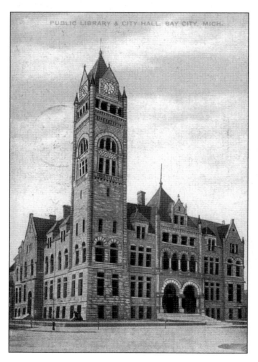

PUBLIC LIBRARY & CITY HALL, BAY CITY, MICH.

PUBLIC LIBRARY AND CITY HALL. Construction of this five-story sandstone building was finished in 1897 after a six-year construction period. It housed all city government offices, the police department, fire commissioner, school superintendent, and the Public Library. The clock was rumored to be water powered although it did not work for a long time. The building design incorporated commerce, industry, a lion's head, a salt block, an anchor, fish, and a saw blade on the front stonework. City Hall was completely restored and rededicated in 1980.

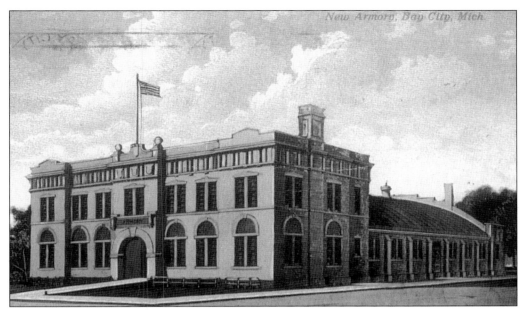

NEW ARMORY. Located west of City Hall on Washington Avenue, the New Armory opened in 1910. Before it became the home of the Bay County Historical Society, it housed many dances and Golden Gloves Boxing matches. It was exciting to view the events from the second floor balcony area. Previously on this site, there had been a block-long wooden armory known to Spanish–American War vets as the "home".

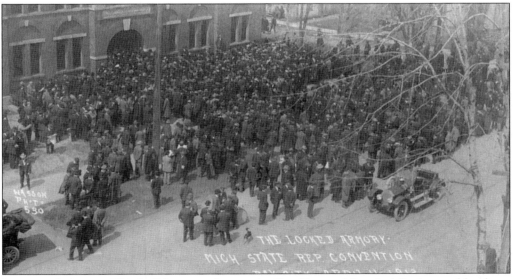

LOCKED ARMORY. This building now houses the Bay County Historical Society and has been totally refurbished. It gained fame when it was involved in one of the events that led to the founding of the Bull Moose Party, after breaking away from the Republican Party—as seen in this 1912 postcard. Supporters of Teddy Roosevelt were locked out and had to climb in through windows to gain entrance. Although Teddy Roosevelt was not present at this event, the Bull Moose Party was one of the biggest third party campaigns in U.S. history.

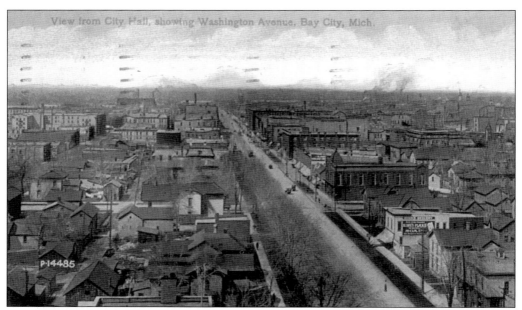

VIEW FROM CITY HALL SHOWING WASHINGTON AVENUE. Looking north down Washington Avenue in 1916 shows private homes mixed in with commercial buildings and salt wells. At the top left is the Wenona Hotel, which replaced the Fraser House that burned in 1905. The Y.M.C.A. is in the center of the picture. You can just see the top of Armory at bottom left.

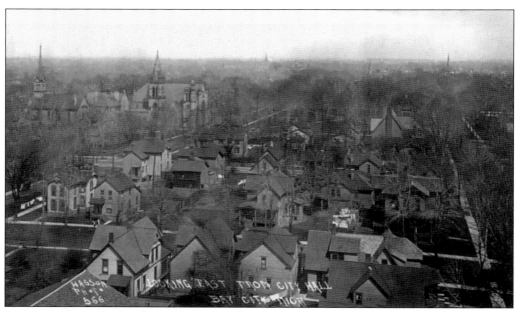

LOOKING EAST FROM CITY HALL. Standing in the same spot on the top of City Hall and looking east, you get a sense of how residential the downtown area was. When Bay City developed, it was along the banks of the Saginaw River. The farther east you traveled, the wilder it got. The two churches at top left are the Methodist Church on Madison and Ninth Avenues, and to its left, the First Baptist Church on Madison and Center. (Courtesy of Tom Sullivan.)

48

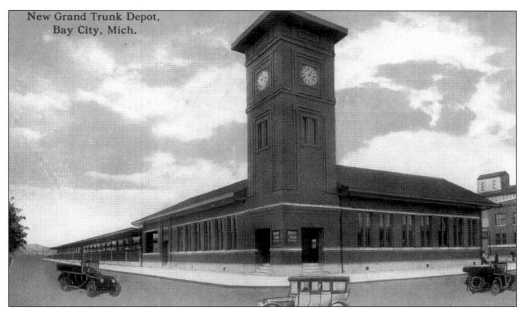

New Grand Trunk Depot,
Bay City, Mich.

NEW GRAND TRUNK DEPOT. Built in 1913, the Cincinnati, Saginaw and Mackinaw Division of the Grand Trunk Railroad was one of three major railroad companies serving Bay City in 1916. The others were Michigan Central and Pere Marquette. The depot and freight house were located at Seventh and Saginaw Streets (just a block west of Center) the site of which in later years housed Sears Roebuck and Company. That site is now the home of Horak Printing.

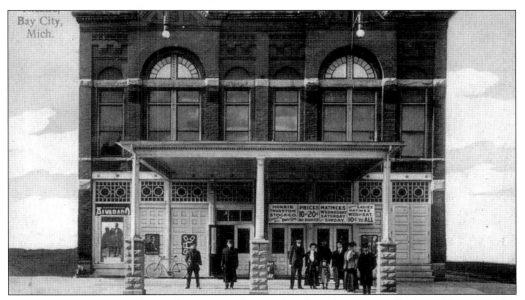

Bay City,
Mich.

ALVARADO THEATRE. One of 13 movie theaters listed in the 1916 Polk City Directory, this theater, which in later years, was known as the Roxy, stood on the southwest corner of Seventh and Washington Avenues. The others were the Aladdin, the Avenue, the Family, the Grotto, the Majestic, the Orpheum, the Park, the Pictureland, the Star, the Temple, the Washington, and the Woodside.

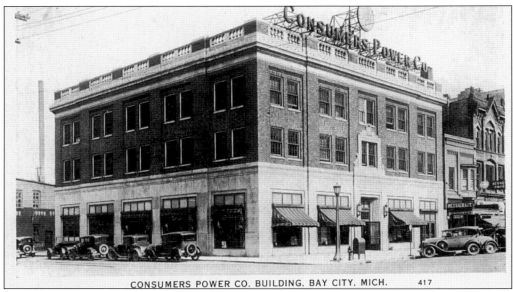

CONSUMERS POWER CO. BUILDING. BAY CITY. MICH. 417

CONSUMERS POWER CO. Consumers Power, which had been located in the Ridotto Building for many years, moved to this location at 701 Washington in 1931 and stayed there until 1974. Until 1927, Bay City had purchased its power from the North American Chemical Company located in the South End. Today, this three-story building (built so that more stories could be constructed) is the home of Citizens Bank.

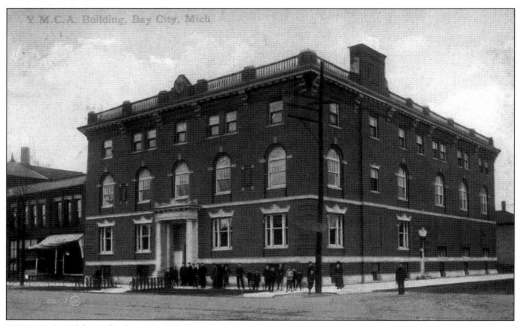

Y.M.C.A. Although there had been an active Y.M.C.A. in Bay City since 1885, this building was not erected until 1908. For 48 years it served as a home for single men. The Y.M.C.A. also actively encouraged sports—especially basketball and swimming. Those sports are still very popular here today. It was replaced by the present building on Madison Avenue in 1954.

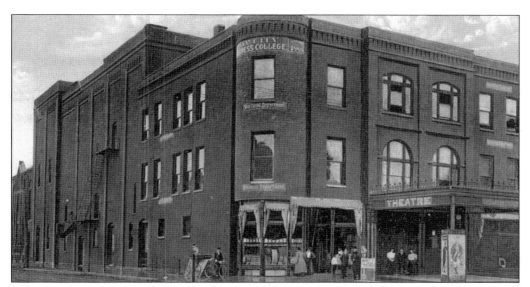

WASHINGTON THEATRE. The Washington was the first motion picture place in town. But, the Washington was more than a movie house; it was a vaudeville house, too. It replaced the Woods Opera House that burned down in 1902, which had replaced the Westover Opera House that had been destroyed in a massive fire in 1886. The Washington Theater survived any fire threat, but was torn down (pretty much intact) in 1963 for a municipal parking lot.

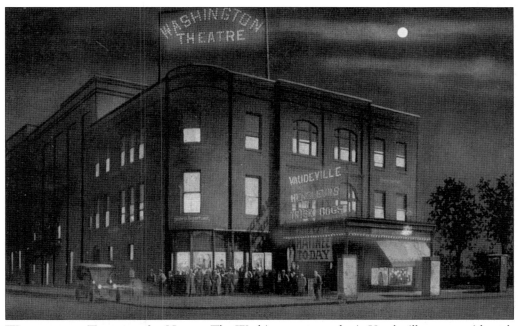

WASHINGTON THEATRE AT NIGHT. The Washington was a classic Vaudeville venue with such celebrated performers as the Marx Brothers and John Phillips Sousa. It had a full orchestra pit which at one time or another held musicians like Isham Jones and Ange Lorenzo. Many schools had graduation celebrations and other functions in its beautiful interior. Tickets for shows ranged from 25¢ all the way up to $1.50.

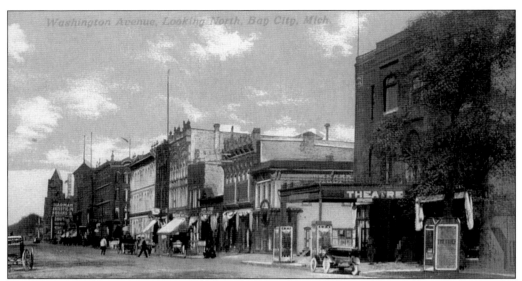

WASHINGTON AVENUE LOOKING NORTH. This postcard shows the beginning of the heart of a vibrant eight-block downtown area. In the center of the postcard are Blanchette and LaPorte Shoes and the William H. Mann Restaurant and Dining Room. The Oriental is probably indicative of the food served and later became the Bay City Café. Many of the buildings north of the Washington burned in a major fire in 1963 but were rebuilt, to include stores like Momberg Camera and Kinney Shoes that are no longer in business.

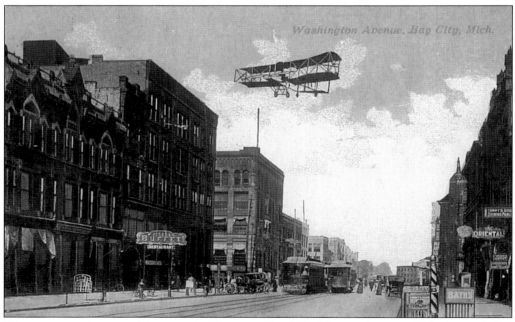

WASHINGTON AVENUE (AIRPLANE). The west side of Washington Avenue still looks much like this today. It just doesn't have a bi-plane superimposed over it like this view from 1913. The Phoenix Building still stands on the southwest corner of Center and Washington and the Crapo Building, with a false front, still stands on the northwest corner.

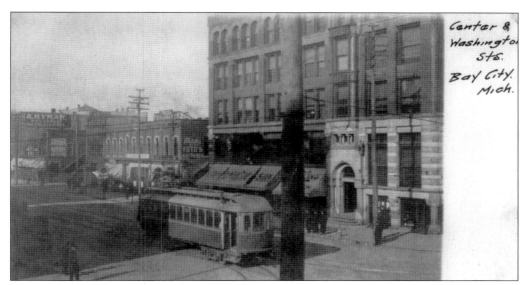

CENTER AND WASHINGTON STREETS. This close-up of the Crapo Block shows a streetcar coming from the west on Center Avenue, approaching Washington Avenue. The banner out front says Oppenheim and Son. That later became Oppenheim and Levy and then just Oppenheim's. This store was special because it had entrances on both Center and Washington (as the Shoe Market has today). (Courtesy of Tom Sullivan.)

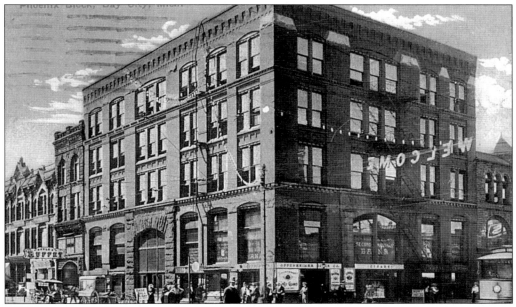

PHOENIX BLOCK. Built initially as a home for the Second National Bank in 1887 on the site of the old Westover Opera House, the Phoenix Block looks much the same today as it did 115 years ago. Only the County Building and the Jennison Building are taller. Today it is the home of Sherman and Sons and the Shoe Market along with several subletting shops. Located in the heart of downtown, the view from the roof is extraordinary according to present owner, Donald Sherman.

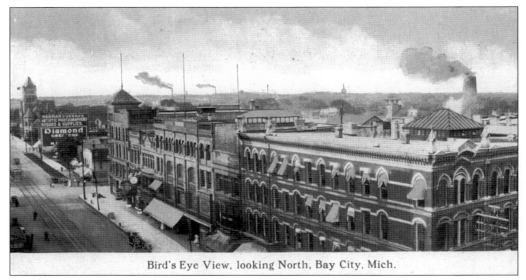

Bird's Eye View, looking North, Bay City, Mich.

BIRD'S EYE VIEW, LOOKING NORTH. Standing on the roof of the Phoenix Building, you would have seen this view in 1912. One of the twin Shearer Buildings (replaced by S.S. Kresge in later years) was kitty corner from the Phoenix. North of that was a group of buildings with the Rose Block at the end. In the distance, you can see the Harmon and Verner Photo Studio and the old Federal Building. Visible just over the roof of the Shearer Building is the turret of the Grand Trunk Depot.

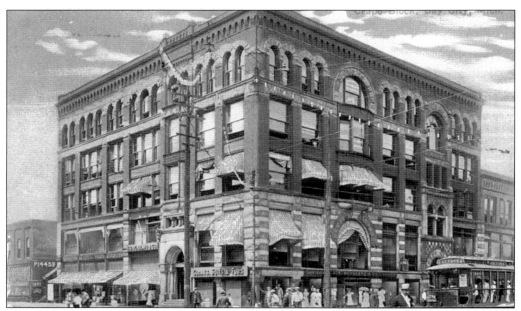

CRAPO BLOCK. As the home of the Bay City Bank from 1871 and Manufacturers' Bank after that, the Crapo (pronounced "cray-po") building was reported in earlier years to have a story or floor below street level. Wendland's Department store occupied the ground floor in later years. In 1905, they advertised the "largest capital" in Bay City with $150,000 plus $1,773,009.93 on deposit. The original building is pretty much intact under its siding cover.

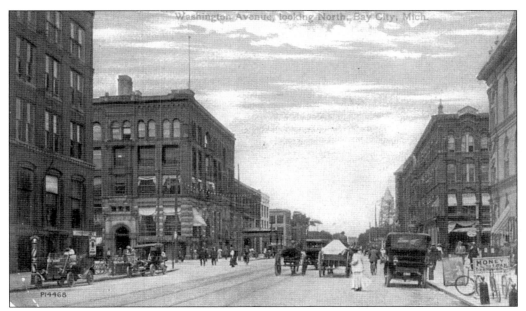

WASHINGTON AVENUE, LOOKING NORTH. The four corners of Center and Washington show up well in this view. From left to right they are: the Phoenix Building, the Crapo Block, one of the Shearer buildings and the First National Bank. Note the marvelous automobiles, the trolley tracks, and that Mr. Tierney has money to lend.

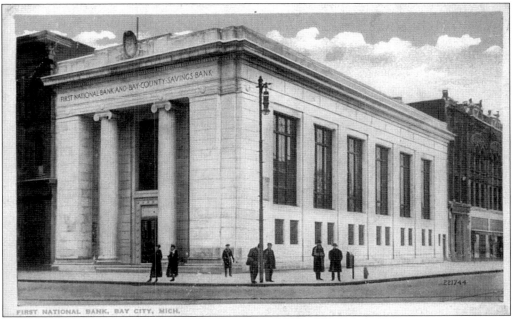

FIRST NATIONAL BANK. Built in 1912 and designed by Albert Kahn, the First National Bank became the National Bank of Bay City in 1932, People's National Bank in 1950, next, First of America and today, National City Bank. Along the way, they remodeled the outside of this classic building but you can still see some of the original stonework.

55

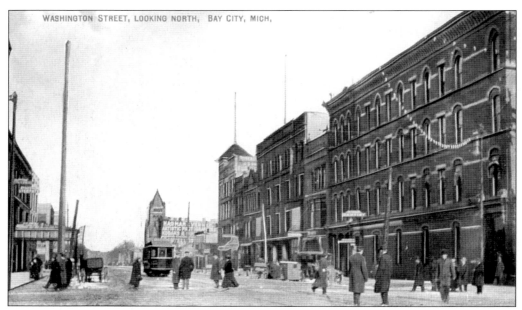

WASHINGTON AVENUE LOOKING NORTH. Doctors, dentists, lawyers, cafeteria, shoe store, notions store and a furniture store filled this block of Washington Avenue including Hawley's Dry Goods Store, the predecessor to longtime favorite, W.R. Knepps. The Harmon and Verner Photography Studio was one of the largest photography studios in town. George A. Harmon dealt in etchings and paintings, Kodaks, supplies, and photo finishing.

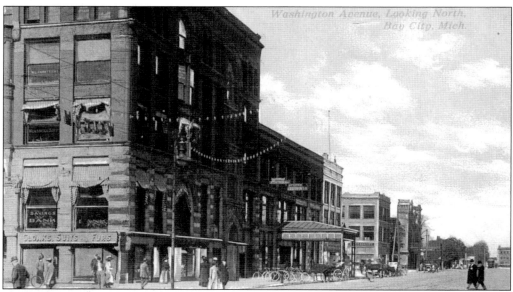

WASHINGTON AVENUE, LOOKING NORTH. The law offices of Weadock and Duffy filled much of the available office space in the upper floors of the Crapo Building. Thomas A.E. Weadock was a corporate lawyer, a Supreme Court justice and a congressman for three terms. Brothers John and George joined him in the law firm. One of Consumer Power's large generating plants was named for John in 1940.

56

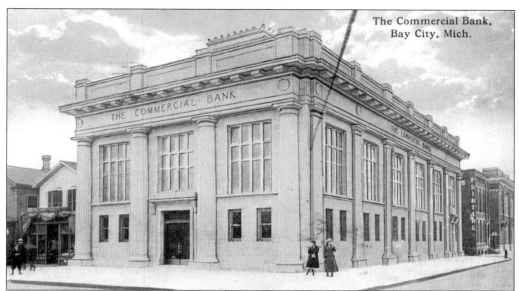

The Commercial Bank, Bay City, Mich.

COMMERCIAL BANK. Like the First National Bank, the Commercial Bank was designed by Albert Kahn and opened in 1912, but its columns made it a stand out. The bank was first incorporated in 1887. In 1905, it was famous for being, "equipped for every feature of modern banking, having safety deposit boxes, burglar proof vaults, and all the conveniences that businesses of the hour demand."

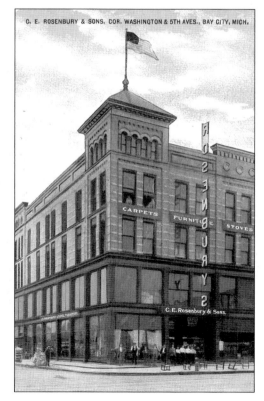

C. E. ROSENBURY & SONS, COR. WASHINGTON & 5TH AVES., BAY CITY, MICH.

C.E. ROSENBURY AND SONS. This quality furniture store was located in the Rose Block until it moved to its last home in the Campbell Block on Water Street, where the Bay City Antiques Center is now located. In 1905 it was one of the four largest furniture stores in Michigan. From the 1940s to the 1960s it was the home of Cunningham Drugs complete with soda fountain. Today it is known as the LaPorte Building.

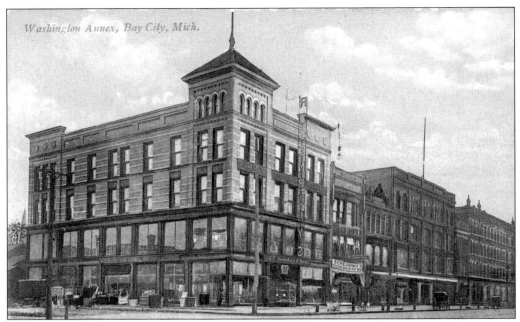

WASHINGTON ANNEX. You can clearly see much of Rosenbury's fine furniture along with Scheurman's Skidoo Sale of Footwear banner. The Rosenbury stock was on four floors and in the basement, too. Besides furniture, they offered special custom upholstering and other house furnishings. In 1906, sons of the original C.E. Rosenbury still ran the store.

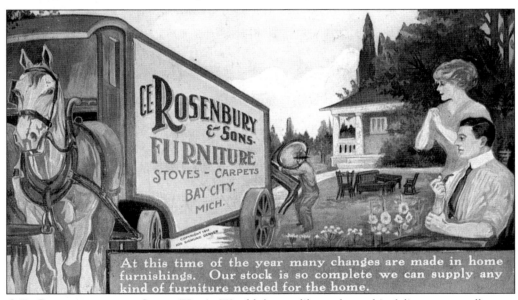

C.E. ROSENBURY AND SONS (VAN). Wouldn't you like to have this delivery van pull up to your house with a furniture delivery? Surprisingly, Rosenbury was one of 19 furniture dealers listed in the 1916 Polk City Directory. Among them were Hawley Dry Goods, Mohr Hardware and Furniture, Rechlin Hardware, See, Utermalen, and H.G. Wendland. Only Utermalens' is still in business today.

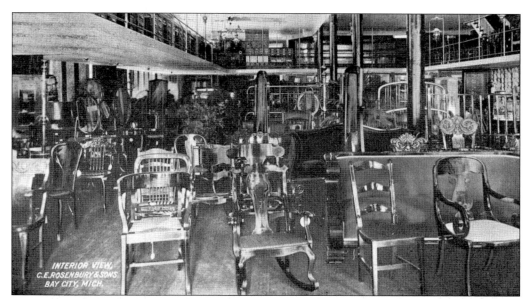

INTERIOR VIEW, C.E. ROSENBURY AND SONS. Oak chairs, brass beds, oak chests of drawers, mirrors, and buffets were for sale. And that's just the first two floors. No wonder they had to put some of their items on the sidewalk. One couldn't walk through the store very easily. There used to be 20,000 square feet filled with furniture. With a sand blasted exterior and a penthouse on the top floor, much of the Rose Block's original beauty has been preserved.

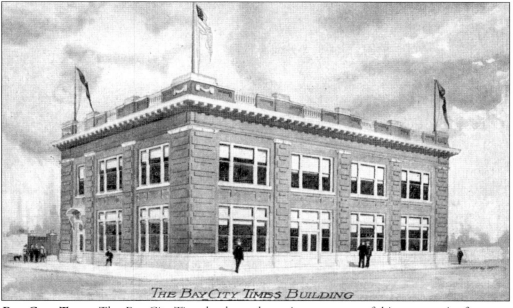

BAY CITY TIMES. The *Bay City Times* has been the main newspaper of this community for more than 112 years. Located just down the block from the Commercial Bank, this building was built in 1910. Although there have been various other morning and evening papers through the years, the *Times* won out as an evening paper. An addition was added in the rear to house larger and faster presses and the building was refurbished some years ago.

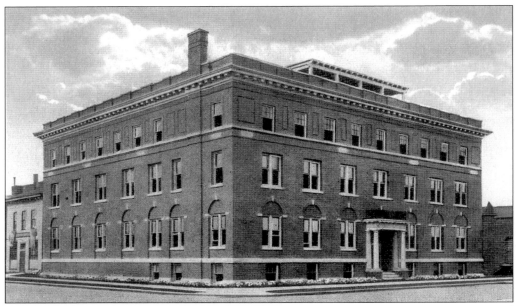

Y.W.C.A. Facing Fourth Street behind the *Bay City Times*, the Y.W.C.A building was erected in 1916. The Young Women's Christian Association of Bay City had been founded in 1891 but had only small facilities until this building was built. The building included a dining room, gymnasium, and auditorium with stage, clubrooms, and dormitories. The original Victrola from the Y.W.C.A. is in my office at Auburn Elementary School. (Courtesy of Tom Sullivan.)

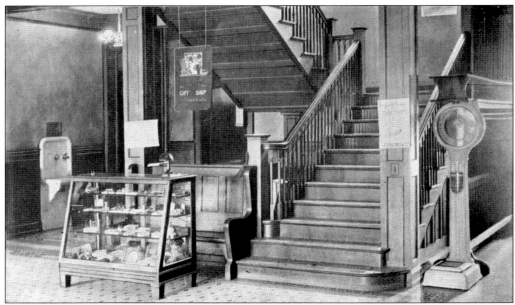

LOBBY, Y.W.C.A. The Y.W.C.A. did not exactly have all the comforts of home, but for that single lady who needed a place to stay or eat, it was very comfortable. The Gift Shop showcase displays many notions a lady might require and the poster on the pillar asks, "Are You a Member of the Cool Ship? Join Now." That doesn't sound a lot different than a membership drive today.

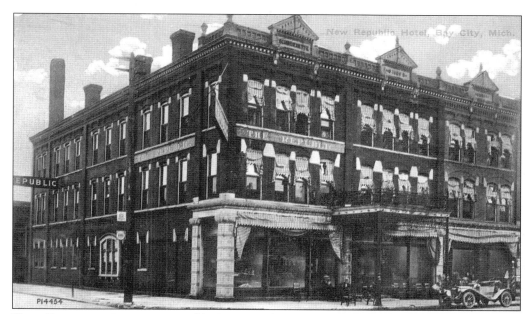

NEW REPUBLIC HOTEL. Just a block west of Washington Avenue on Saginaw Street and Fourth, the Republic Hotel was built in 1883. It had 60 rooms for guests, including sample rooms, steam heat, electric elevator and bell service, private and public baths, spacious lobby, and good food. During the lumbering years it was often the hotel of choice for lumbermen and sea captains. It was torn down in the late 1960s.

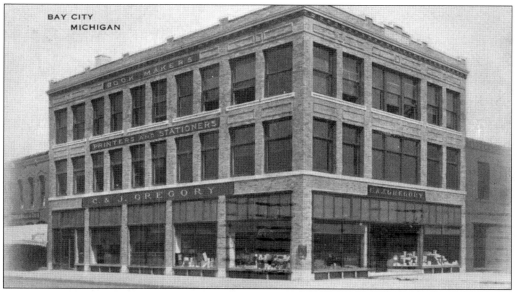

C. AND J. GREGORY. Back on Washington Avenue, one of Bay City's finest local printers was C. and J. Gregory. Gregory presses published many of the publications written about Bay City at the turn of the century like *Bay City Illustrated* from 1898 and *Bay County Past and Present* from 1918. The building looks much today as it did when built and is now the home of the Music Center.

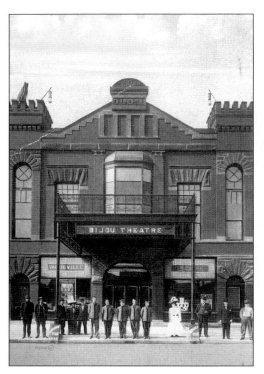

NEW BIJOU THEATRE. When the New Bijou was built in 1908, it didn't look like any other movie theatre in town. Its refurbishing in 1930 in the Art Deco style gave it an ancient look. Mayan themes were used with the plaster having a rust-colored look. Over the years the name changed from the Bijou to the Bay to the State. It is once again in the midst of being renovated with the hopes of attracting a family crowd.

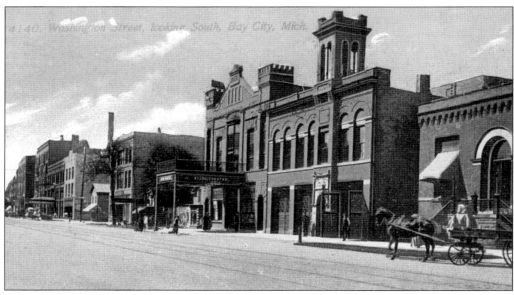

WASHINGTON STREET, LOOKING SOUTH. Going from right to left (north to south), you see the Michigan State Telephone Company, the Fire Headquarters building (right in the heart of the downtown of course), the Bijou Theater, the lot where C. and J. Gregory would build and the Crapo and Phoenix Buildings on the far left. Flora M. Spore had a dentist's office in the Phoenix. She was Bay City's first female dentist. Today, a travel agency is located in the building on the far right.

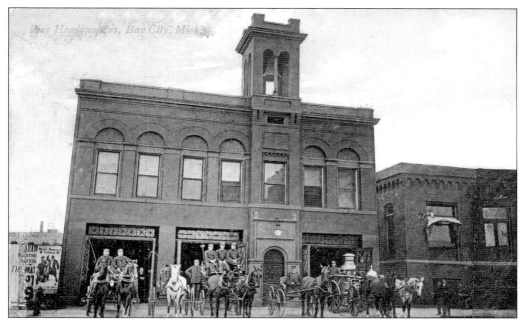

FIRE HEADQUARTERS. Horses were used by the Fire Department through 1918 and they also used volunteer firefighters until 1919. In 1918, 100 fire alarm boxes were located on the east side and 31 on the west side. When there was a fire, a person in the location of the firebox with a firebox key would ring the closest station. That station would send equipment and call for help as needed.

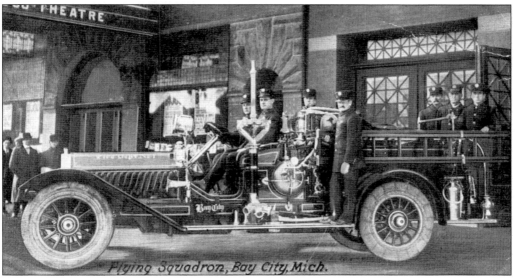

FLYING SQUADRON. After being driven to fires by horses, you can see why their replacement—a motorized vehicle—would get the name "Flying Squadron." Chief Thomas K. Harding had been in charge of the fire department almost continuously since 1883 until he died in 1912. He led the fight for a motorized department and also for locating the "new" central fire station at McKinley and Adams.

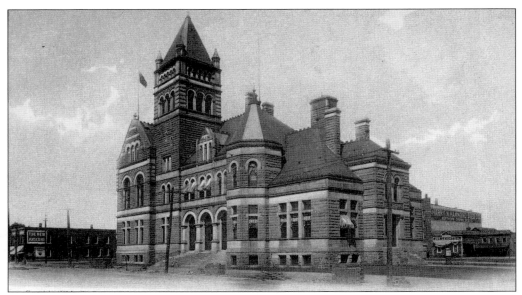

U.S. FEDERAL BUILDING. When the new Federal Building opened in 1931, people referred to this building as the "Old Post Office." Located nearly at the northern end of Washington Avenue, it was an impressive stone building. Not only did it have the Post Office on the first floor, but it also housed federal offices, courtrooms, judges' offices, and customs offices. When it was torn down, block was salvaged for use on a private home on North Lincoln Street.

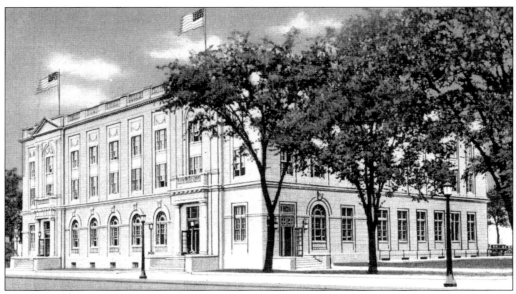

U.S. POST OFFICE AND CUSTOM HOUSE. Federal funds paid for the replacement of the old U.S. Federal Building on the same location. It contained most of the offices and courts that the former building had held, but never suffered from the "shoddy construction" reputation of its predecessor. When this building opened, you could find offices for Internal Revenue, U.S. Marshall, U.S. District Attorney, Prohibition, Public Health and the U.S. Signal Service in addition to the Post Office.

Five
CENTER AVENUE

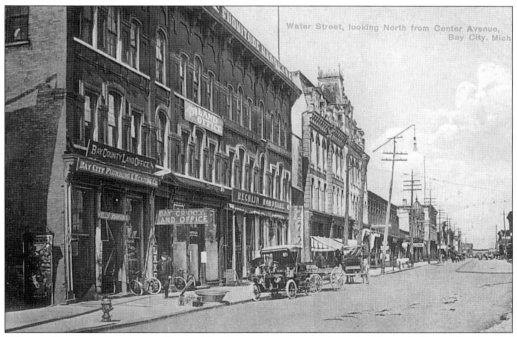

WATER STREET (FOOT OF CENTER). If you were to stand at the foot of Center in front of where the Friendship Shell is today looking north nearly a hundred years ago, this was the view you would have seen in 1904. This street was often described as "Hell's Half Mile." The lumbermen went here to spend their hard earned wages in the many saloons, hotels, and houses of ill repute. Just before the turn of the 20th century it was the toughest neighborhood in the city.

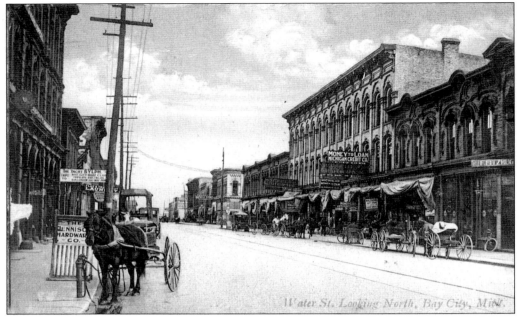

WATER STREET LOOKING NORTH FROM CENTER. Even though it was the road to Hell's Half Mile, Center and Water Streets had many appealing commercial enterprises. On the left was the Bay City Tribune Building. Just north of the Tribune was the Sylph boat rental agency and a laundry. Directly across the street was the Michigan Credit Co., who were willing to lend money to nearly everyone, and the famous Walther's Cheap Store which sold a little bit of everything. In the distance is Tierney's Bicycle Shop.

TIERNEY'S BIG STORE. Located a block north of Center and Water, Tierney's Big Bicycle Shop carried bikes, wheels, fishing tackle, and other sporting goods and loaned money as well. The Tierney brothers were also major real estate agents. Peter was located in the Tierney Building and brothers Edward and James lived over their saloon just north of their bike and loan business.

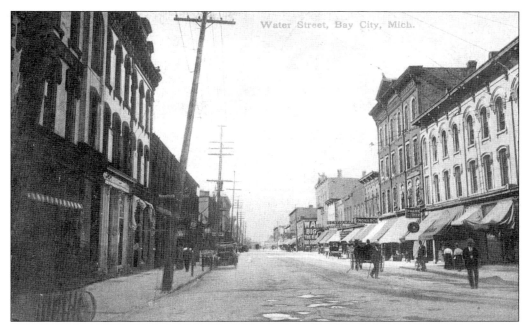

WATER ST. LOOKING NORTH (FOOT OF CENTER). This last view of Water Street from the foot of Center Avenue is an example of how Bay City grew along the banks of the Saginaw River. The far northern end of this view led to the approach to the Third Street Bridge. This was the area that supposedly had trap doors and tunnels connecting the saloons that allowed over-boisterous drinkers to escape the police or even other saloon patrons.

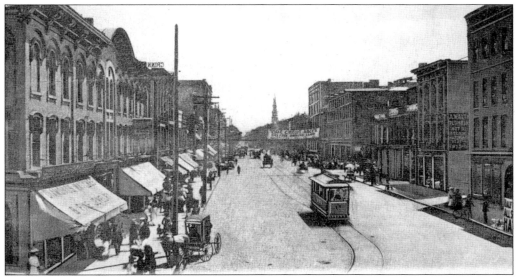

CENTER AVENUE (TROLLEY). With Herman Hiss Jewelry Store on the left and the Fraser House Hotel on the right, this was truly the "center" of town. The Fraser was run by the Goodwin brothers and was the leading hotel in town for almost 40 years. You can just see the hat sale sign of C.D. Vail who was on the ground floor of the Fraser for the last 30 of its years, offering a full line of hats and haberdashery.

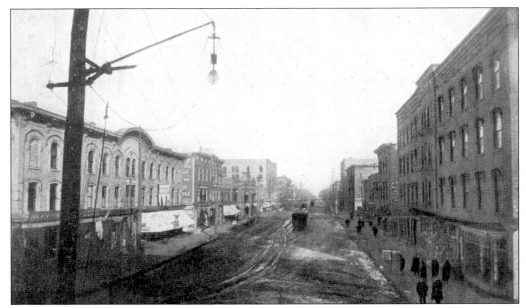

CENTER AVENUE (FRASER HOUSE). The Fraser House was a solid brick building with 75 guest rooms with full electric lights, bell service, steam heat, and private baths. Other amenities included an elevator, spacious lobby, cozy parlor, and a magnificent dining room—or so it was stated in 1905. The Fraser House was the place to stay in Bay City at the end of the 19th century and in the first few years of the new century.

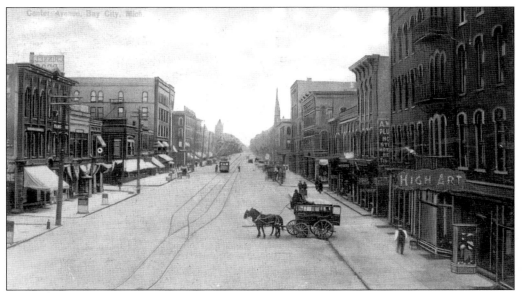

CENTER AVENUE (WAGON). Many of the community leaders and politicians used to gather at the Fraser House. James Fraser had been one of the founding fathers of Bay City. The Fraser House had been the site of the earliest phone demonstration in the city and it was the first public building to be wired for electricity. Interestingly enough, this card is dated 1910, four years after the Fraser House burned down.

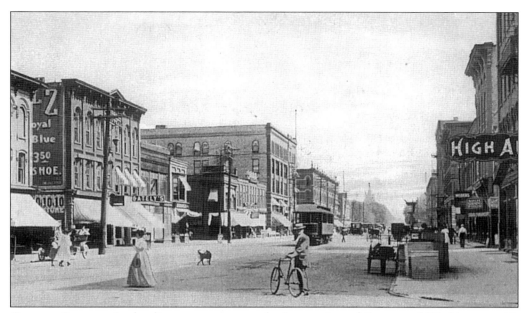

CENTER AVENUE. In the distance you can see the intersection of Center and Washington with the Crapo Block, the Shearer Building, the Bank Building, and the five-story Phoenix Building. Across from the Fraser House are the Union Painless Dentists and Gately Shoes. Grinnell Music Store was there for many years, too. Across from Gately's was Weber's Shoes and yet another pawnshop. The right side of the block was about to change.

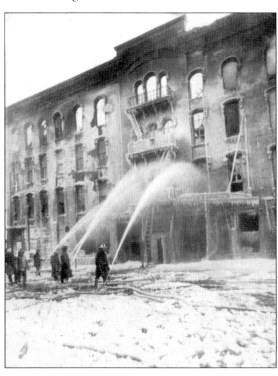

DESTRUCTION OF THE FRASER HOUSE. When the Fraser House burned on December 23, 1906, it marked the passing of Bay City's most famous landmark at the time. No guests were killed because of the low occupancy due to the holiday season. It was a bitterly cold day and one fireman died fighting the blaze. Because the fire hoses could only reach the third floor of this four-story building, the blaze was pretty much unstoppable.

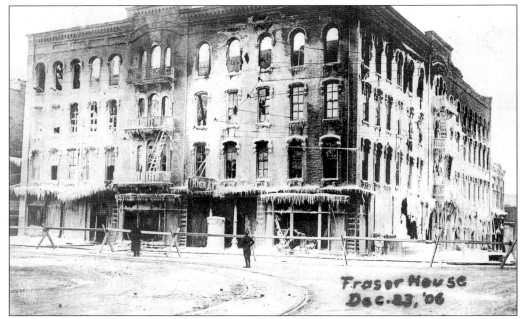

Fraser House
Dec. 23, '06

FRASER HOUSE. "The fire at the Fraser House was an imposing spectacle and this scene with the ice-covered ruins in the days following the fire were impressions never to be forgotten by those who witnessed them," according to remembrances in a 1918 history of the Bay City Fire Department. That blaze was the department's greatest battle to date and led to the modernizing of the stations and equipment and to the revitalization of the downtown.

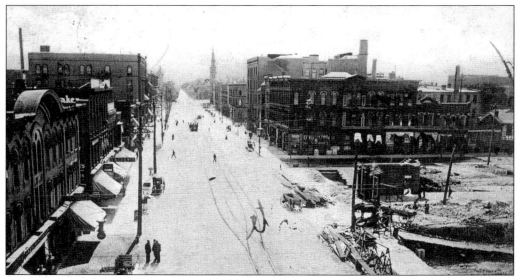

CENTER AVENUE (CONSTRUCTION). When the Fraser House burned, it opened the door to urban renewal. The Wenona Hotel replaced the Fraser, and the Tribune Block (where the Friendship Shell now stands) was torn down and replaced by a park—Wenonah Park, of course. Businessman, A.E. Bousfield, took only nine weeks to come up with a plan for a $300,000 replacement in early 1907, one that was "elaborate and palatial" according to the *Bay City Tribune*.

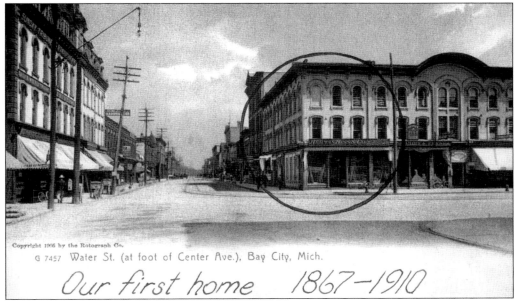

G 7457 Water St. (at foot of Center Ave.), Bay City, Mich.

Our first home 1867–1910

WATER STREET (HISS JEWELRY). Here is one last view of the earliest commercial district that was built along the river. The circled building was that of Herman Hiss Jewelers (still in business today on Washington Avenue) and now the long-time home of the Mill End Store. The Watson Block on the left (which led to "Hell's Half Acre") was razed in 1909 to house a park complimenting the "New Wenonah Hotel."

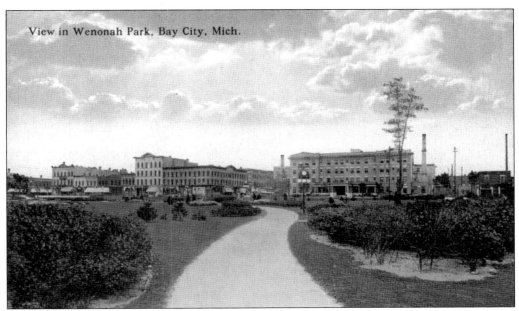

View in Wenonah Park, Bay City, Mich.

VIEW IN WENONAH PARK. When the Watson Block succumbed to a major fire in 1909, the large Wenonah Park was developed on its ashes. That gave visitors at the Wenonah Hotel an unobstructed view of the Saginaw River. Much of the same needs are met today with the Friendship Shell standing in the center of what was once Wenonah Park.

71

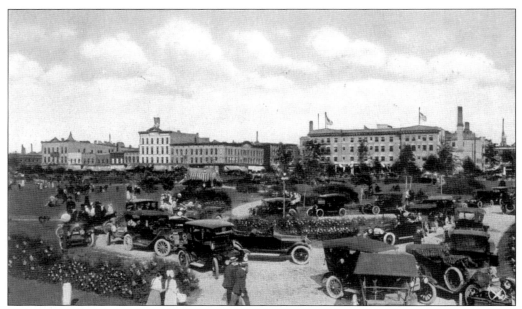

WENONAH PARK AND HOTEL. This picture must have been taken on a Sunday judging from all of the cars in the park. The message on the back of this 1925 card states," I'm having a dandy time. Going on a week's trip to Alpena. This is a very beautiful place. Annie." You can just bet Annie enjoyed the luxurious Wenonah Hotel and the beautiful Wenonah Park.

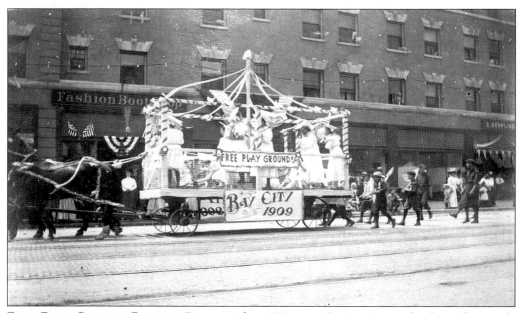

FREE PLAY GROUND PARADE. For more than 100 years, Center Avenue has been the parade route in Bay City, from the Water Carnival Parade leading to the public pool in Wenonah Park in the past—to the St. Patrick's Day Parade held now. The message of the "Free Playground's" float passing in front of the new Wenonah Hotel in 1909 is lost in history and one can only guess. Notice the Sempliners and Fashion Boot signs.

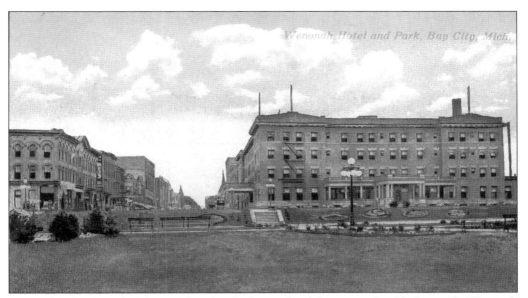

WENONAH HOTEL AND PARK. This view looks east from the new park with the stately Wenonah Hotel on the right. The business district extended six blocks to Madison Avenue. The Wenonah opened in 1908 and covered most of the block bounded by Center, Water, Saginaw, and Sixth Streets. It was named for the Indian maiden in the Longfellow poem, "Hiawatha."

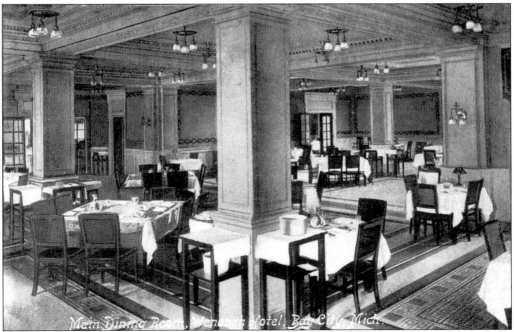

NEW DINING ROOM, WENONAH HOTEL. In his marvelous description of the Main Dining Room, Dale Patrick Wolicki says it was "...located on the first floor to the south of the lobby, featured wood wainscoting enameled in soft ivory, paneled walls tinted sage green and gold, ceiling finished in old ivory and mosaic tile floor." It was class all the way.

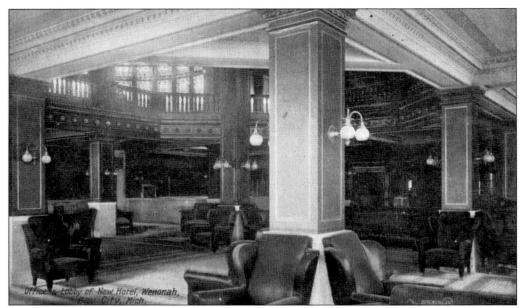

OFFICES AND LOBBY OF NEW HOTEL, WENONAH. Once again, using Dale Wolicki's description, the lobby "…featured a central two story octagonal rotunda. To the right were the staircase and elevators, the latter wrought iron enclosures finished in bronze. The registration desk was located immediately across the lobby. To the left was the entrance from Center Avenue and a large fireplace of stone…"

LADIES PARLOR, WENONAH HOTEL. When the Wenonah opened, it had 2,500 electric lamps, 250 radiators, 395 tons of steel, 2,875,000 bricks, and 83,000 square feet of fireproof sanitation (which was ironic considering how rapidly it burned in 1977). It contained two passenger elevators, a barbershop, a ladies' hair dressing parlor, and a tailor shop.

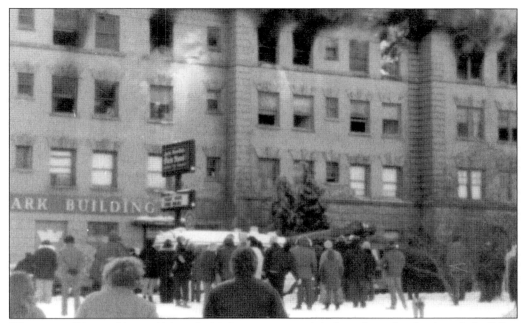

WENONAH HOTEL FIRE. Although this is not a postcard, it does show the demise of a building that was touted as "the only absolutely fire-proof hotel north of Detroit" in 1908. When it burned on Friday, December 9, 1977, 10 lives were lost, making it the costliest in human lives in Bay City fire history. Many people jumped to safety but at least three died from their fall. Seven died from smoke inhalation. Like the fire 71 years before, ice covered the burned building.

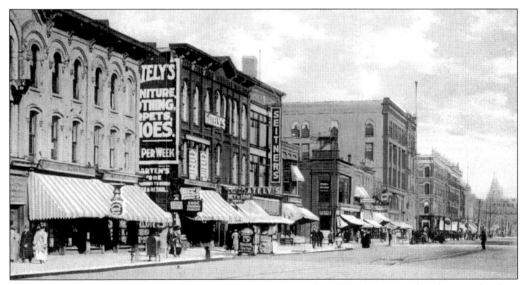

CENTER AVENUE (SEITNERS). Gately's was a chain store handling ladies cloaks, skirts and tailor-made suits, boys' items, children's clothing, carpeting, furniture, and shoes on the "cash or credit" plan. Seitner's was a dry goods store with Morris Seitner as president. The same block contained a bookstore, millinery and fancy goods store, the Union Painless Dentists, and a tailor shop just west of the Crapo Building.

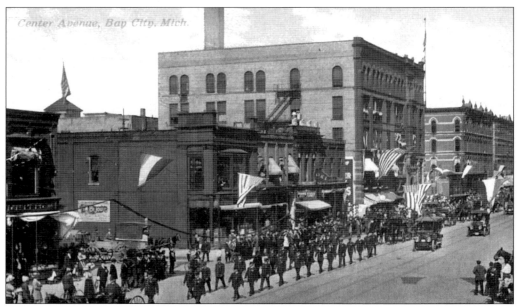

CENTER PARADE. This is another Center Avenue parade, this time in 1914. Although the purpose of this parade is unknown, it does seem to have a lot of police. Possibly it is a 4th of July Parade, as there are flags flying. Notice the poster on the building in the center of the picture advertising the Bijou Theater and the trade sign for O and L Shoes in the shape of a shoe.

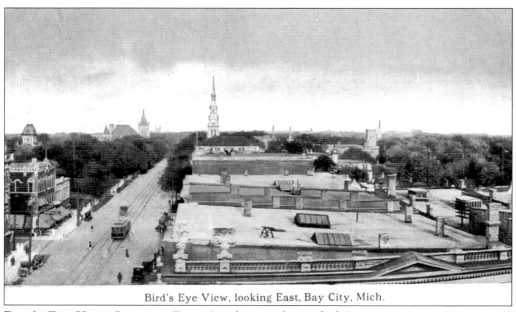

Bird's Eye View, looking East, Bay City, Mich.

BIRD'S EYE VIEW, LOOKING EAST. Standing on the roof of the Wenonah Hotel, you could see a long way down Center Avenue. On the left is the Frantz Drugstore and beyond it is the old Courthouse. On the horizon, in the center, are the First Presbyterian Church and the First Baptist Church. In the center to the right is the Madison Avenue Methodist Church, the only one of the mentioned buildings that is still standing.

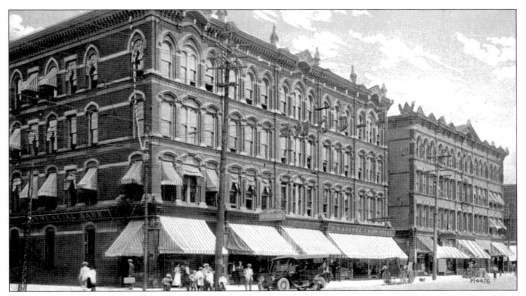

SHEARER BUILDING. James Shearer was an architect involved with the construction of the Michigan State Capital Building in Lansing and many buildings in Detroit, so it was only fitting to have the twin Shearer Buildings in the center of town on the corner of Center and Washington. Partnered with his brother in Shearer Brothers Real Estate for more than 25 years, they owned the handsomest office and business block in the city and handled the bulk of choice real estate.

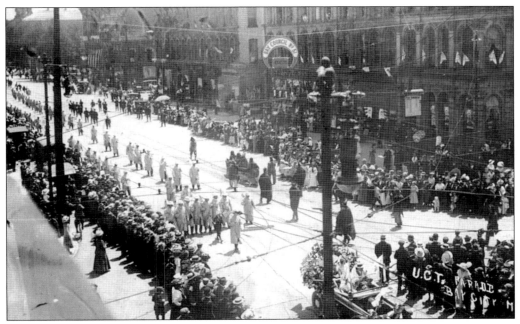

U.C.T. PARADE. The United Commercial Travelers, Bay Council No. 51 liked to have parades, too. The U.C.T. was a national fraternity-like benefit organization for salesmen (Commercial Travelers) that provided benefits much like our labor unions of today. This parade seemed to have a lot of participants and spectators, so the insurance business must have been good.

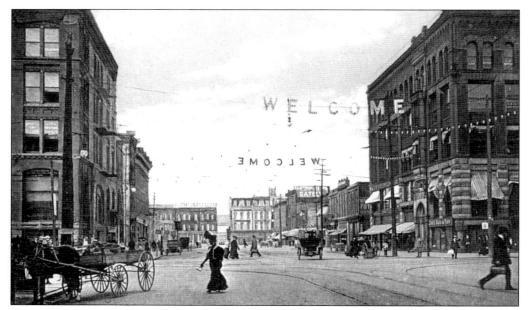

CENTER AVE, (AND WASHINGTON). The busy intersection of Center and Washington in about 1907 shows the Watson Block at the west end of Center Avenue. This included Rechlin Hardware, C. and J. Gregory and the Bay City Tribune Building that burned in 1908 and was razed in 1909 to become the new Wenonah Park. The "Welcome" banners were a part of the community's efforts to be known as a friendly place to be. The slogan at the time was "Bay City—The Glad Hand Town."

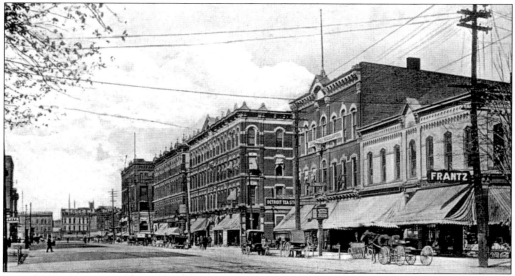

CENTER AVENUE, LOOKING WEST. This view is about two blocks to the east of the previous one. You can see the west end of Center and also the twin Shearer Buildings, which included the Detroit Tea Store in the one that still stands today and the Franz Drugstore that was selling Coca-Cola all those years ago. For many years, C.H. Franz dispensed prescription drugs and sodas and was the place to buy your Kodak cameras and film.

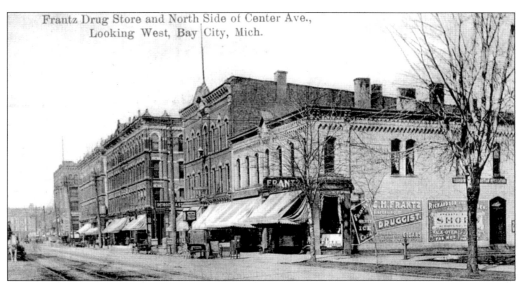

Frantz Drug Store and North Side of Center Ave.,
Looking West, Bay City, Mich.

FRANTZ DRUG STORE AND NORTH SIDE OF CENTER AVE. When you took the trolley west on Center, you knew you had reached the downtown part of town when you saw the Franz Druggist sign. In addition to his soda fountain, he sold his own brand of Frantz Velvet Ice Cream that was made in his factory on N. Monroe Street. The store later became Bebb Drugs. To the west was the Detroit Tea Store where you could purchase teas, coffees, spices, extracts, baking powder, and crockery. My wife's grandfather, Bert Tuttle, worked there in the 1920s and 1930s.

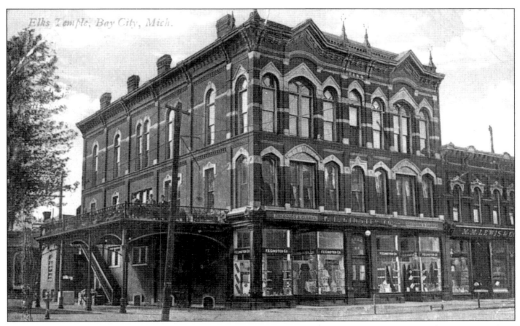

ELKS TEMPLE. Across the street from Franz Drugs was the Elk's Temple. Not only was it a place for social gatherings, but it was also a great place to eat for many years. The Elks Temple building was also home to F.E. Ginster Dry Goods and Cloaks Company and to the west was the dry goods store, M.M. Lewis Company. Notice the men sitting on the outdoor terrace having lunch.

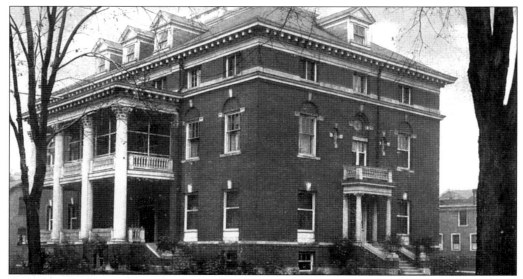

BAY CITY CLUB. Built in 1904, the Bay City Club provided meeting areas, fine dining, private reading rooms, and pool tables for local politicians and businessmen. It had public and private dining rooms—and even a women's hall. Many people used the facilities for private parties and weddings but it was torn down and replaced by a bowling alley in 1940.

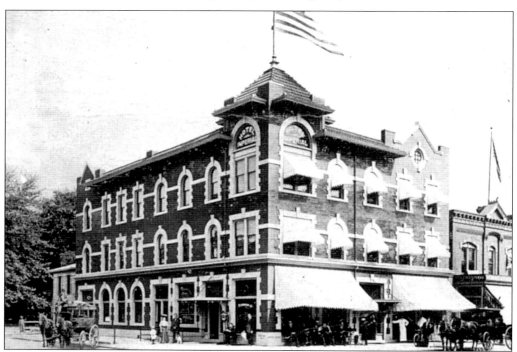

HOTEL IMPERIAL. Located just across the street from the Bay City Club, one block north of Center, the Hotel Imperial was built of sandstone brick. It had 21 rooms, electric lights, steam heat, a barbershop, a sample room (bar), and every other feature a modern hotel could have in the first decade of the new century. It was located between the Grand Trunk Depot and the downtown.

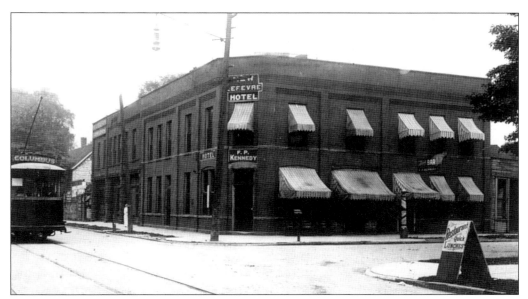

NEW LEFEVRE HOTEL (COLUMBUS TROLLEY). The New LeFevre Hotel was about six blocks east of the Hotel Imperial, across from the Michigan Central Depot on N. Jackson Street. F.P. Jackson was the proprietor for many years. Notice the Columbus Avenue Trolley Car and the signboard offering "Quick Lunches." The person who sent this card wrote on the back that he had arrived and was waiting for the 1:10 train.

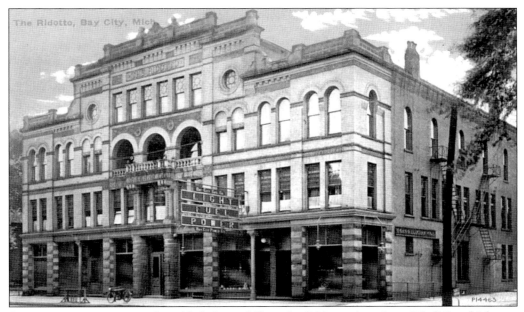

RIDOTTO. For years, people paid their gas bill at the Ridotto (my Aunt Lil did), which was located across from the courthouse, just west of Madison Avenue on Center Avenue. It had been built in 1896 as a place for Bay City's "dancing elite" according to a *Bay City Times* article and was large enough to hold concerts for 500 people. This building met the same fate as many others and burned in a major fire on April Fool's Day in 1940.

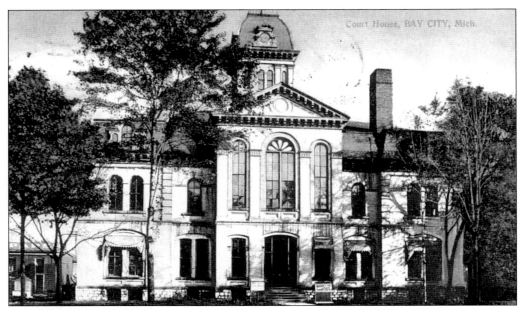

Court House, BAY CITY, Mich.

COURTHOUSE. The Courthouse was built two years after the Civil War ended and was torn down to be replaced by the present County Building in 1932. The original two-story building was made of yellow brick sandstone and contained offices for the county clerk, treasurer, judges, and county sheriff much as the County Building does today.

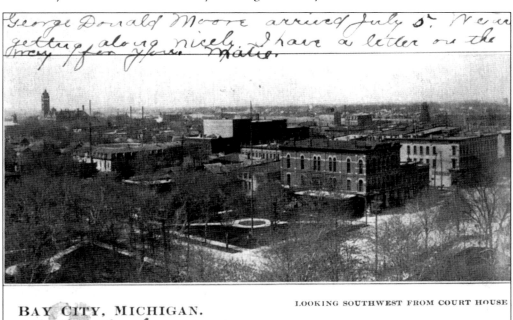

George Donald Moore arrived July 5. New getting along nicely. I have a letter on the way for you. Mattie.

BAY CITY, MICHIGAN.

LOOKING SOUTHWEST FROM COURT HOUSE

LOOKING SOUTHWEST FROM COURTHOUSE. The cupola at the top of the Courthouse gave an excellent view of the city. In the far distance on the left, City Hall is visible. Battery Park is in the foreground and the twin Shearer Buildings can be seen on the right. On the horizon is the Saginaw River and West Bay City can be seen across the Saginaw River.

COURTHOUSE. Dwarfing all other buildings, Bay City's County Building was built in the depths of the Depression era on the site of the old courthouse located at Center and Madison. It is nine stories high and constructed of solid limestone in the Art Deco style. There was ample space for county supervisors, county clerk, circuit courtrooms, register of deeds, and treasurer, as well as spectators. The entire building was renovated in 1984 and it is listed on the National Register of Historic Places.

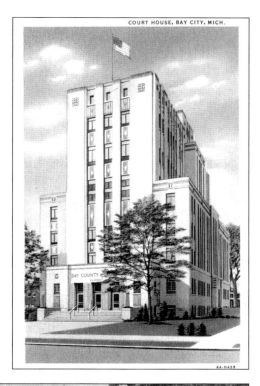

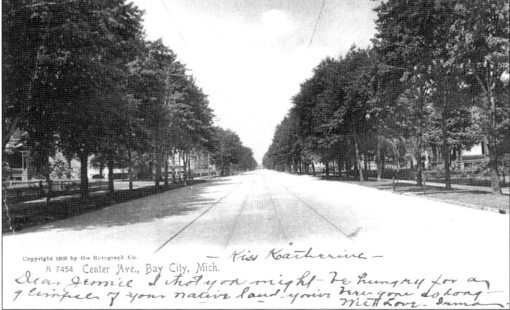

CENTER AVENUE (LOOKING EAST). This postcard and the one that follows were taken from the exact same spot on Center Avenue with this one looking to the eastern part of town. Center was (and is) a broad tree-lined street with houses built by the lumber barons and ship owners. This 1908 view also shows the trolley tracks leading out of town and the phone lines overhead.

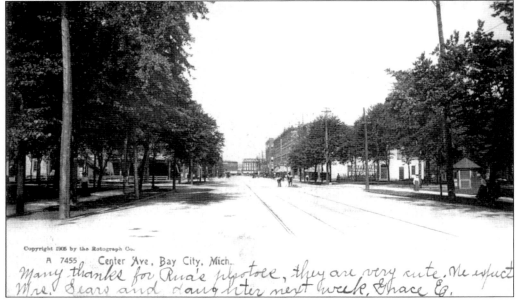

Many thanks for Rua's photoes, they are very cute. We expect Mrs. Sears and daughter next week, Grace E.

CENTER AVENUE (LOOKING WEST). Like the postcard before it, this view was taken at about Center and Madison in 1905, but it faces west toward the downtown area. You can see the twin Shearer Buildings in the center of the picture and the Watson Block on the west end of Center Avenue. Even the Franz Drug sign is visible just below the tree line.

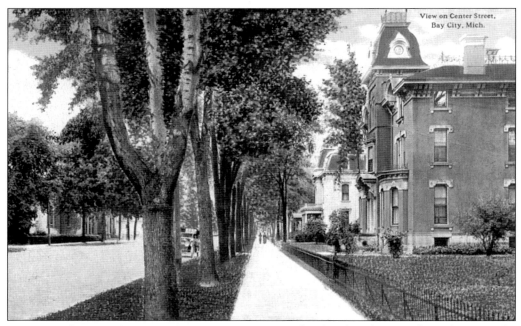

View on Center Street, Bay City, Mich.

VIEW ON CENTER STREET. Center Avenue was and is lined with magnificent homes. The home of James Shearer at 701 Center was no exception. Built it 1876, it was a family home nearly 30 years before being used as an apartment building. The tower has a widow's walk with iron railings. Mr. Shearer could view his many properties from this vantage point.

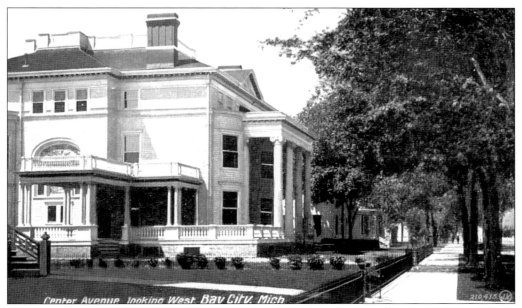

CENTER AVENUE, LOOKING WEST. Alfred Bousfield was president of the Bousfield Woodenware Works and the Delpheon Phonograph Company. His 14,000 square feet home at 1200 Center (now the Colonial Apartments) was built in 1892. It, too, had a widow's walk on the roof. Its four massive columns always drew the eye of the viewer. The living room featured 14-foot ceilings and a freestanding staircase to the second floor.

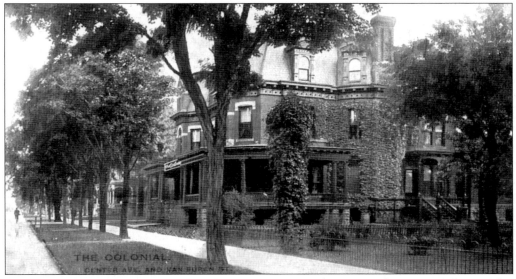

THE COLONIAL. The old Colonial stands at 814 Center on the corner of Van Buren Street. After 1920, it was known as the Young Apartments and even later as the Kulman Apartments. The proprietor, Charles D. Vail, owned C.D. Vail and Co., a place to buy men's hats and shirts to measure. At one time, the Colonial was known as Bay City's largest private hotel. Its first owner was W.D. Young, who was president of the Bay City Brewing Company among other things.

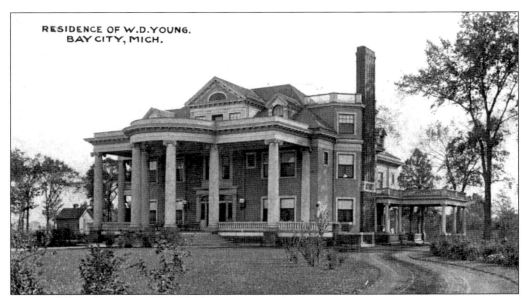

RESIDENCE OF W.D.YOUNG.
BAY CITY, MICH.

RESIDENCE OF W.D. YOUNG. As one of the most prominent factory owners in town, it was only fitting that the home of W.D. Young be one of the finest. Located at 2300 Center Avenue, it had the finest hardwood floors that the W.D. Young Mills could produce. Its majestic pillars and widow's walk were features that drew the eye. Bay City historian, Barb Eichhorn remembers sitting on W.D.'s lap when she was a young child.

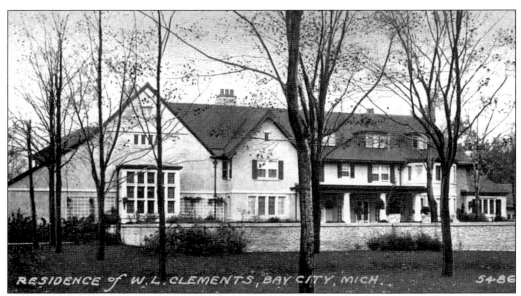

RESIDENCE of W.L. CLEMENTS, BAY CITY, MICH. 54-86

RESIDENCE OF W.L. CLEMENTS. As the owner of the Industrial Works, William Clements qualified as one of the biggest industrialists in Michigan. His home on 2201 Center Avenue was designed by Albert Kahn and constructed in 1910. The rooms were large and the land was more like an estate than a yard. The showpiece of this mansion was the library, which housed William's rare book collection, now kept in the Clements' Library at the University of Michigan. The carriage house is all that remains today on the corner of Park and Center Avenue.

Six

SCHOOLS

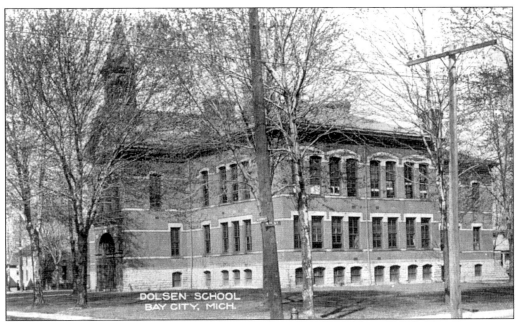

DOLSEN. This kindergarten through eighth grade, 14-room school was built in 1883. Its principal from 1891 to 1910 was Sarah Dolsen, whose husband, John, owned the Dolsen Sawmill located nearby on the Saginaw River. Assemblies were held in the upper hall. Dolsen was the first Bay City school to have a kindergarten. The original building was replaced in the 1950s. The present building is currently used for storage by the Bay City Public Schools.

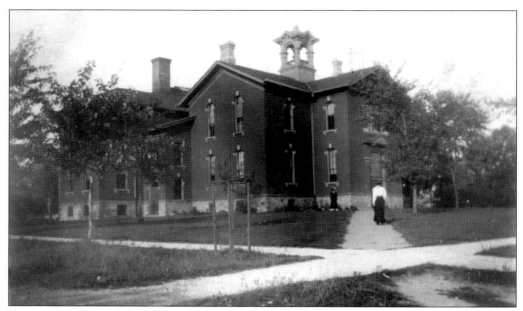

FREMONT SCHOOL. The Fremont School opened in 1875 and its namesake still stands today on the corner of Fremont and Broadway, but it is no longer a public school. Helen MacGregor, longtime principal of Fremont, was one of the MacGregor sisters for which today's MacGregor School was named. Fremont started as a four-room school but grew to 12 after a series of additions. (Courtesy of Barb and Pete Eichhorn.)

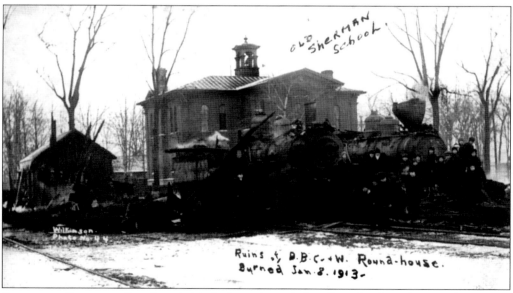

SHERMAN SCHOOL. Standing behind the ruins of the Detroit, Bay City and Wenona Roundhouse is the Sherman School, which was built in 1874 as an eight-room school to replace the First Ward School. It was located on the corner of Sherman and Woodside. In 1923, it had a staff of seven teachers and an enrollment of 225 students. It also had a room for deaf children. (Courtesy of Barb and Pete Eichhorn.)

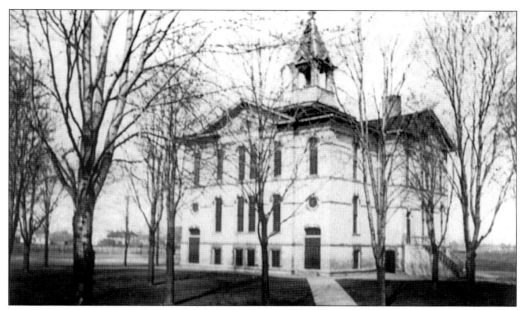

WHITTIER SCHOOL. Known early on as the Seventh Ward School and then the McGraw School, the seven-room Whittier School was built in 1874 on a location distant from homes "because no one wished a school near their dwelling" according to the *School News* of 1923. Four rooms were added in 1907. In 1908, the Teacher Training School was located there where it remained for eight years before moving to Riegel School. (Courtesy of Tom Sullivan.)

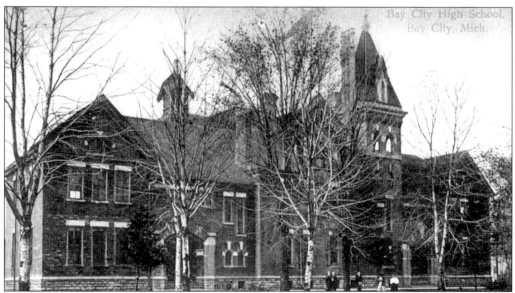

BAY CITY HIGH SCHOOL. In later years, this was known as Eastern Junior High, located on the site of the present Y.M.C.A. on Madison Avenue. It burned in a spectacular fire in 1937. The building was erected in 1883 to replace the aging High School built on Farragut Street in 1867. The location was considered better—as the Farragut location had been condemned as being too far out of the city. (Farragut was six blocks to the east.) The enrollment was over 500 in 1923.

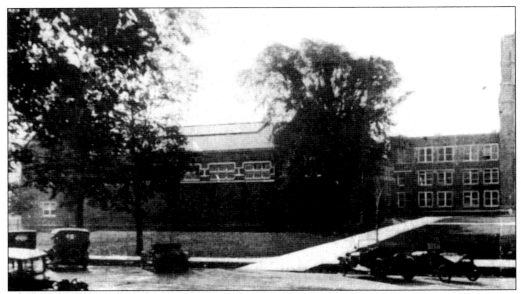

CENTRAL (LEFT 1/2). When the two Bay Cities merged, both Eastern and Western High Schools were in desperate shape. Elections were held every year from 1912 through 1920 until the decision was made by the Board of Education to build a new high school and Junior College. That led to the construction of Central High School that opened in 1922 and had its first graduating class of 170 students in 1923.

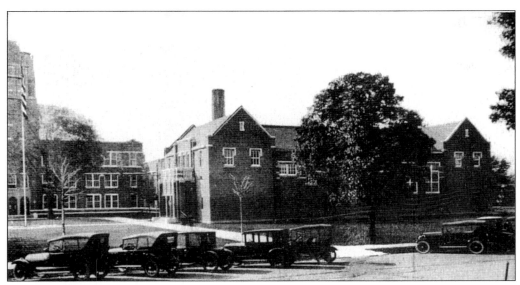

CENTRAL (RIGHT 1/2). Central High had 53 staff members when it opened in 1922, teaching both in the High School and Junior College, which was to remain there until the opening of Delta College in 1961. Over the years there have been many additions and upgrades to the original building and stadium. The parking was moved to the back many years ago and cars of this nature have not been seen for nearly 80 years.

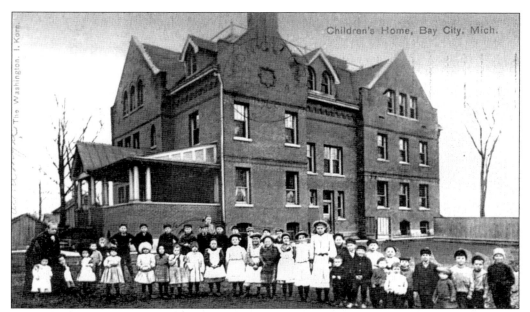

CHILDREN'S HOME. Not all of these children were orphans. If your parents were too poor to care for you, you might have lived here four or five years before they came to take you back. In later years, Bay City Public Schools used it for their Administration Building until it was razed in 1981. The building was located directly east of Central High School on Johnson Street.

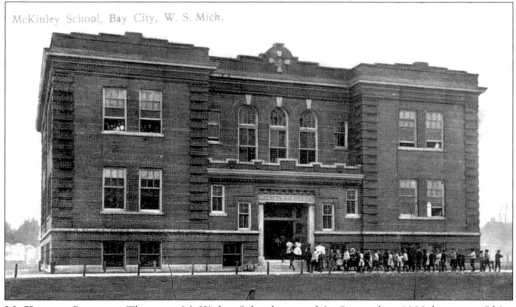

MCKINLEY SCHOOL. The new McKinley School opened in September 1908 between Ohio, Blend, and Vermont Streets on Bay City's West Side. It was built to take students from Dennison and Central Elementary Schools and help with the overcrowding at Park and Wenona Schools. It had two firsts in the city: indoor toilets and playground equipment. Miss Betty Heath remembered teaching her kindergarten in this building while the present McKinley was being constructed.

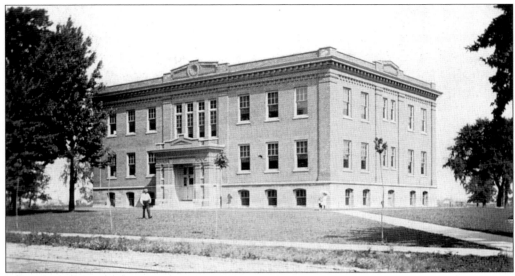

RIEGEL SCHOOL. Originally, there was a three-room Riegel School on the same location built in 1878. The new eight-room Riegel opened in 1907. They were very proud of their building and grounds. In fact, that is the janitor, Mr. Popp, standing out front. The students considered him the best in the world because he "magically" cleaned up mud, dust and fingerprints as fast as they appeared.

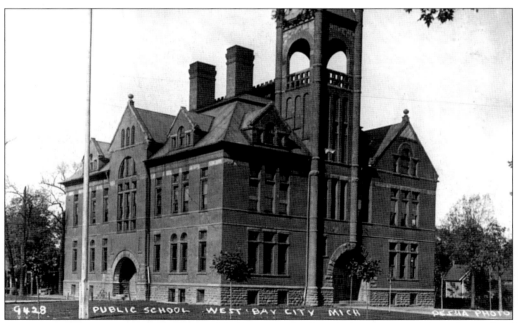

PARK SCHOOL. Located where the Litchfield grove of oak and elm trees stood directly north of St. Mary's Church, Park School was built in 1885. Park had eight classrooms and was rumored by former custodian Al LaMarre, to have had a haunted bell tower. Because of its age, the inadequacy of the site and the fact that Dorland School had been enlarged, Park closed in the mid-1950s. (Courtesy of Tom Sullivan.)

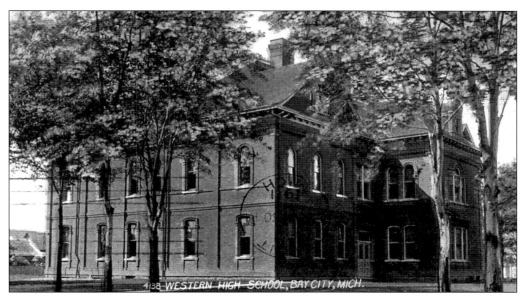

WEST SIDE HIGH SCHOOL. The site of the present Allen Medical Building on South Wenona Street is where the original Western or West Side High School stood until its last graduating class of 1922. That last year saw an instructional staff of 21 teachers and Mr. Wendell Perkins as principal. Fifty-one students were in the final graduating class. The underclassmen transferred over to the new Central High School and the junior high students to the new T.L. Handy.

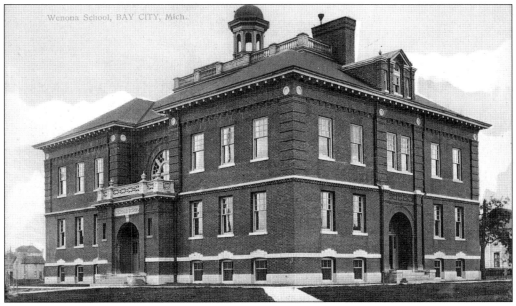

WENONA SCHOOL. Constructed as an eight-room school in 1906, Wenona preserved the name of the village of Wenona on the west side when the two Bay Cities merged. In 1913, it became the site of all manual training for west side schools. Though having limited playground space, Wenona was centrally located and housed 249 pupils in 1936, a little under its capacity of 280. The present-day Wenona houses Bay City's Alternative School. (Courtesy of Tom Sullivan.)

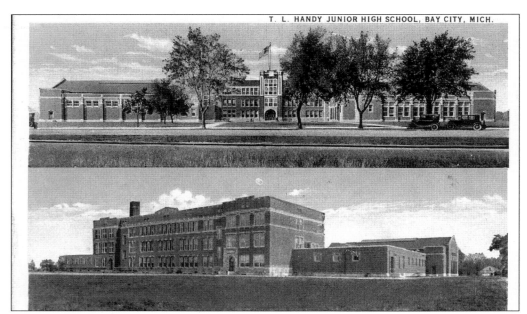

T.L. HANDY JUNIOR HIGH SCHOOL, BAY CITY, MICH.

T.L. HANDY JUNIOR HIGH SCHOOL. Thomas Lincoln Handy Junior High School opened in 1922, thanks in part to the donation of the land by the Bay City lumberman. It housed 500 students in its first year, and opened before all construction was completed. The gymnasium opened in early April and the cafeteria at the end of April. It is still in use today as the largest middle school in Michigan.

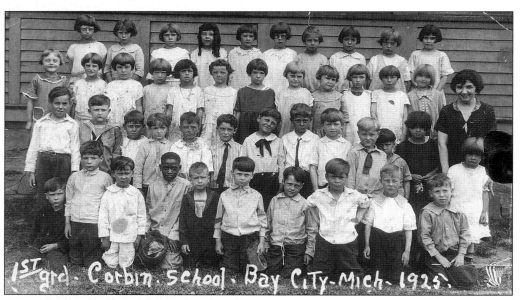

FIRST GRADE, CORBIN SCHOOL. Corbin School was built in 1890 on land given by Captain Benjamin Pierce to serve the Banks community and the workers of the Wheeler Shipyard. Initially a two-room school, two more rooms were quickly added. When coal mines opened nearby, a fifth room had to be added. It was replaced by the modern Dorland School in 1951 which now serves as the Administration Building for the Bay City Public Schools.

Seven

CHURCHES

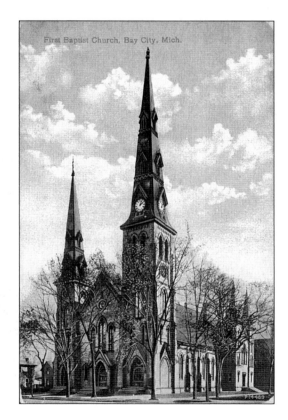

First Baptist Church, Bay City, Mich.

FIRST BAPTIST. Long a landmark on the corner of Center and Madison with its tallest spire rising 180 feet, it was erected in 1874 and served a congregation of which Bay City pioneer, James Fraser was a member and benefactor. It was located on the corner between the Consistory and Masonic Temple—two buildings that still stand. The church was visible from nearly every tall building in the city.

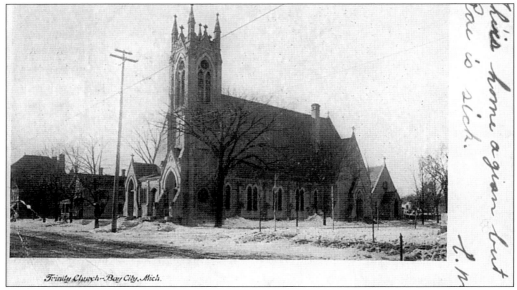

TRINITY. Trinity Episcopal Church owed its establishment to another pioneer Bay City family, the Fitzhughes. Still standing on the corner of Grant and Center, it traces its members back to 1854. The church organized "missions" in Wenona, Portsmouth, Essexville, Banks, and McEwanville. Trinity Episcopal has served the community continuously from this location since about 1885.

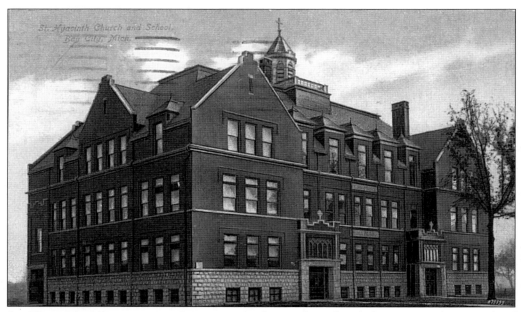

ST. HYACINTH CHURCH AND SCHOOL. As the number of Catholics rose on the east side of Bay City, the need grew for more churches to serve the various ethnic populations. St. Mary served the French, St. Stanislaus served the Polish people in the South End, St. Joseph served the earliest lumberman of various backgrounds, and St. Hyacinth Church was established as a Polish Church on Michigan Avenue between Cass Avenue and 35th Street.

MADISON AVENUE M.E. On the corner of Madison Avenue and Ninth Street today stands Created For Caring, a community-helping group. It is located in the former Madison Avenue Methodist Episcopal Church, one of the first churches built after Washington Avenue, the original site for all churches by plat provision, became too commercially developed.

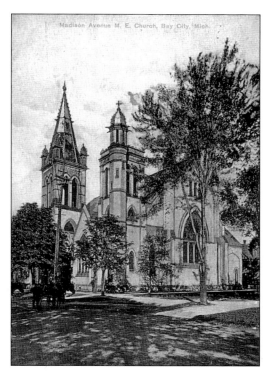

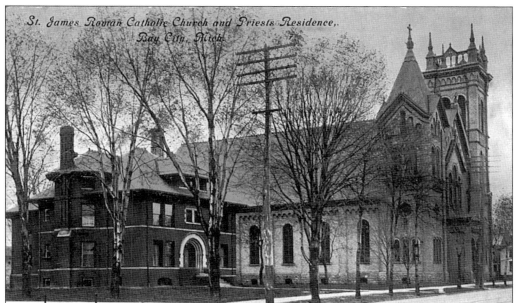

ST. JAMES ROMAN CATHOLIC CHURCH AND PRIESTS' RESIDENCE. Due to the overcrowding of St. Joseph Church, St. James Church was built on Columbus Avenue in about 1870. It was replaced with the building in this picture in 1886 when the original church burned. Ironically, this St. James burned after being hit by lightning and was itself replaced by a more modern structure.

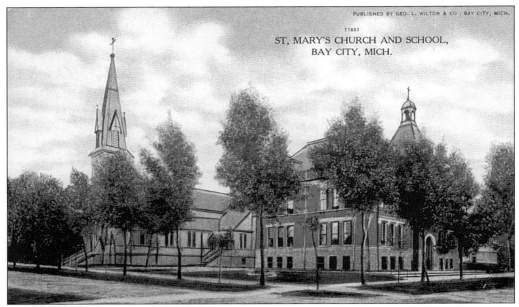

PUBLISHED BY GEO. L. WILTON & CO., BAY CITY, MICH.

11851

ST. MARY'S CHURCH AND SCHOOL,
BAY CITY, MICH.

ST. MARY'S CHURCH AND SCHOOL. Located across the street from the Park Public School, St. Mary's School was strong competition for the public school children. The church itself was built in the 1870s to serve the French settlers in Banks and Wenona. It is still a viable Church on the west side of Bay City, although the school has been closed for a number of years.

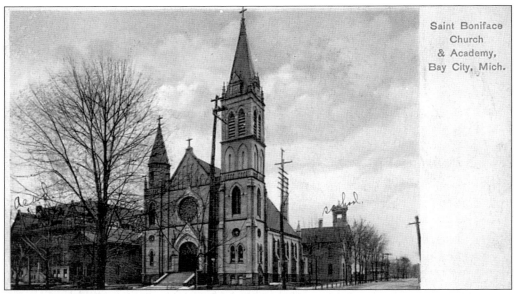

Saint Boniface
Church
& Academy,
Bay City, Mich.

SAINT BONIFACE CHURCH AND ACADEMY. Saint Boniface was built to serve the German population on Lincoln Street (between Sixth and Eighth Streets) during 1875-1876. Its early members were proud to have it be the first church consecrated in the diocese because the bills were paid and the building had been blessed. When a new school was built in 1922, Mrs. Kathryn VandenBrooks remembers students had the job of carrying the textbooks from the old school to the new one.

ST. JOSEPH'S FRENCH CATHOLIC CHURCH

Before St. Joseph Church was built, priests had to come from Flint and Detroit. A small church was constructed on Third and Farragut Streets in 1852. The present building, (the one in this postcard) was the third one on the same site. It was completed in 1911. Pratt and Koeppe, the same local architects who designed the Sage Library, St. James Church, City Hall and the Masonic Temple, designed St. Joseph Church.

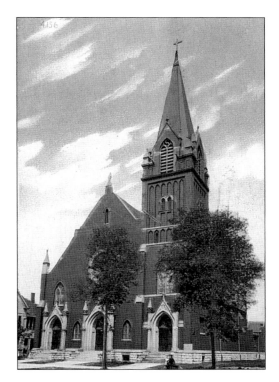

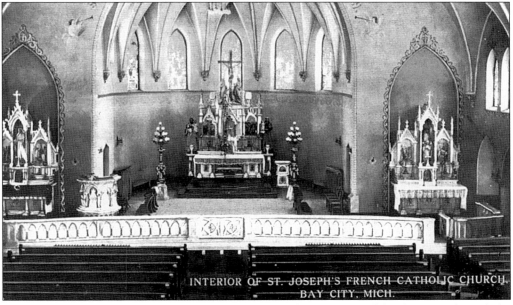

INTERIOR OF ST. JOSEPH'S FRENCH CATHOLIC CHURCH.
BAY CITY, MICH.

INTERIOR OF ST. JOSEPH'S. What a delightful view of the interior of this fine French Catholic Church more than 90 years ago! Changes were made to the interior during Vatican II in the 1960s, but this postcard preserves an old look. The benches were not comfortable, but they were sturdy. There are 44 French Cathedral stained glass windows in the original 1907 interior construction that name all the original donors.

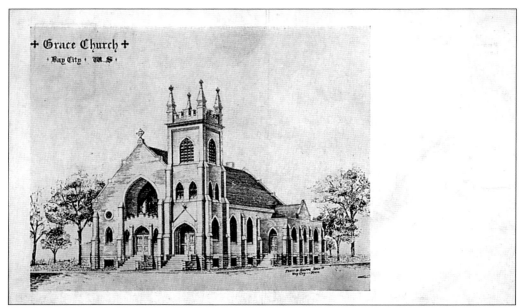

GRACE. Grace Episcopal Church is located on the corner of Midland Street and South Erie. The present congregation can trace its roots back to 1893. The old Presbyterian Church was purchased, repaired, and opened in 1899. Some time later, the members of Grace moved into this building, where they still worship today. In 1924, Bay City had 56 churches.

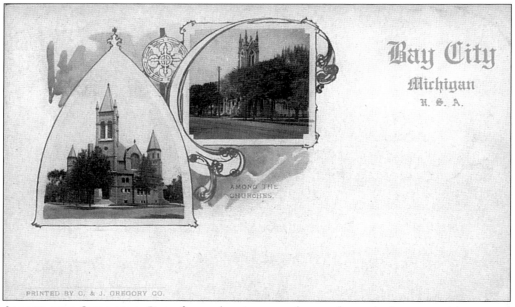

AMONG THE CHURCHES. Part of a set showing two photos of a particular genre, this postcard shows the First Presbyterian Church on the left and Grace on the right. Opening in 1893 after two years of construction, Grace is located on Center Avenue just a few blocks east of the downtown. The church was inspired by Bay City presidential candidate, James Birney, and designed by local architects Pratt and Koeppe.

Eight
WENONA BEACH

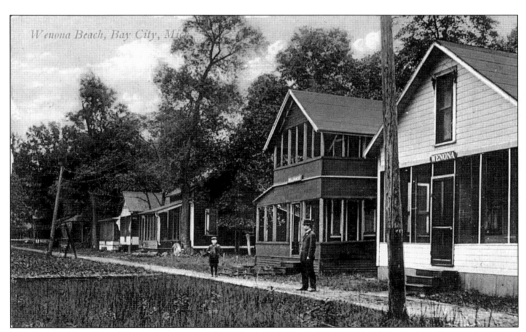

WENONA BEACH. There was actually a beach with cabins located next to Wenona Beach Amusement Park that was adjacent to the Saginaw Bay at the end of Patterson Road. It opened in 1891 and closed in 1964. *Wenona Beach* author, James R. Watson, speculates it closed due to age, problems with ice damage and the opening of interstate highways.

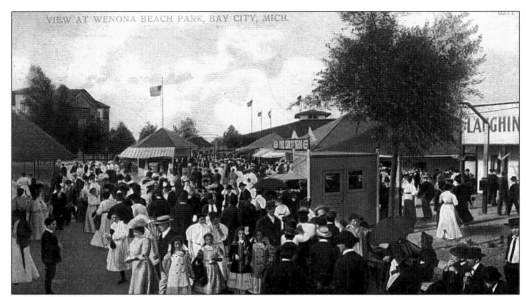

VIEW AT WENONA BEACH PARK, BAY CITY, MICH.

VIEW AT WENONA BEACH PARK. Children and adults liked the Midway at Wenona Beach. It was a carnival every day with chances to win prizes for you or a loved one. People dressed up in their best clothing and rode the streetcar that they caught near the Belinda Bridge. In the early days, it was 10¢ to ride in an open car or 15¢ for a closed one. Mrs. Dore remembered liking the open car so that her beau would have to put his arms around her.

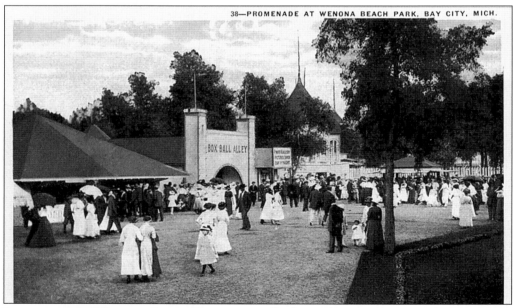

38—PROMENADE AT WENONA BEACH PARK, BAY CITY, MICH.

PROMENADE AT WENONA BEACH PARK. Box Ball Alley. What a great name! This game lasted until 1915. In the 1940s, Nate Doan, who ran a Santa School for many years, had a french fry stand on the Midway and was involved in play-by-play announcements for Detroit Tiger games. A telegraph reported balls, strikes, hits, and outs and Nate's broadcast over the radio simulated live coverage.

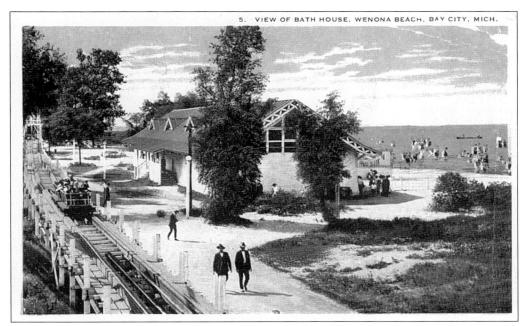

VIEW OF BATH HOUSE. The original Bath House and Circular Swings were completed in 1902; both were destroyed by ice in 1913. This version was erected shortly after and stood right next to the Jack Rabbit, a wooden-structured roller coaster that rose to a height of 75 feet. The portion shown in this postcard was where the Jack Rabbit ride was completed.

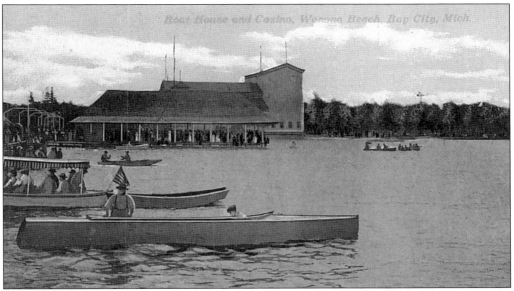

BOAT HOUSE AND CASINO. Before the Wenona Beach Amusement Park was built, the site had been used for boat rides and excursions. When Wenona Beach opened, that didn't change. It was possible to rent dock space for a boat or to rent a boat by the hour or day. The docks themselves were filled with spectators watching boat races—much like spectators line the banks of the Saginaw River to watch the River Roar today.

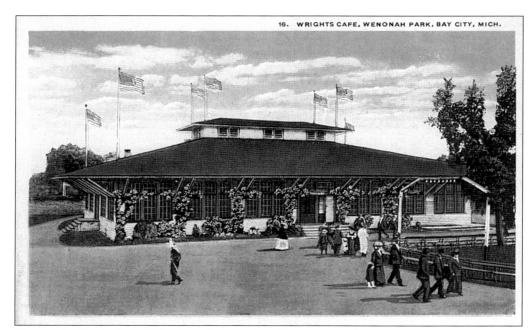

WRIGHT'S CAFÉ. David Wright built his café and ice cream parlor in 1901. It was large enough to seat 550 people. Wright's Café had a whitefish dinner that could be purchased for 50¢. David was the owner of the park in 1926 when he sold it to Otto Pierce, Hoyt Smart, and Otto Sovereign. His home was just west of the Bath House on the west side of the park.

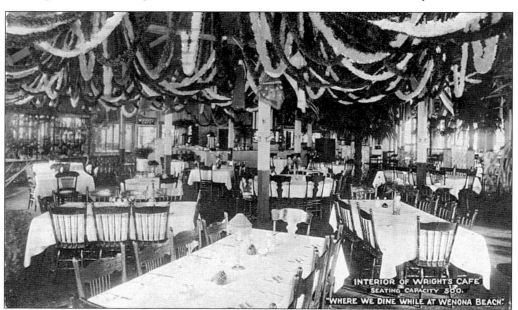

INTERIOR OF WRIGHT'S CAFÉ. According to the author James R. Watson, the inside of Wright's Café was "airy and well-lit offering a hushed, comfortable atmosphere." David Wright died in 1926 and Wright's Café became the new Casino. As the Casino, it was a stopping place for many big band acts, including Tommy and Jimmy Dorsey, Isham Jones, and Guy Lombardo.

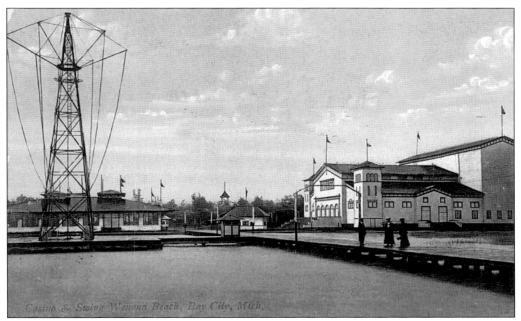

CASINO AND SWING. Destroyed by the ice storm of 1913, the Swing Ride has been gone for nearly 90 years. But the memories of Wenona Beach are alive for anyone who ever rode the Bullet (Rolloplane), bumped in the Bumper Cars, or rode the Jack Rabbit. The author and fellow high school seniors rode the shaky Jack Rabbit over and over in Wenona Beach's' final summer of 1964 hoping to be on it when it collapsed. It never did.

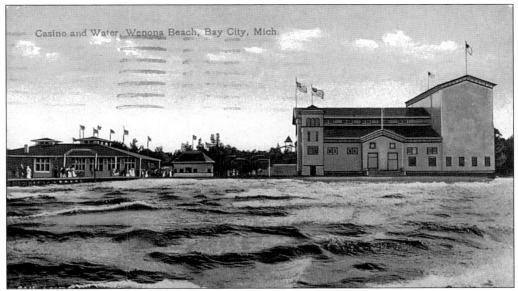

CASINO AND WATER. The Casino was 100 feet high and built on wood pilings. In earlier years, it was the scene of Vaudeville shows and performers. In later years, besides hosting big bands and dances, operas were performed and it housed a roller skating rink. Vaudeville performers included W.C. Fields, the Marx Brothers, and Marie Dressler, with two shows a day.

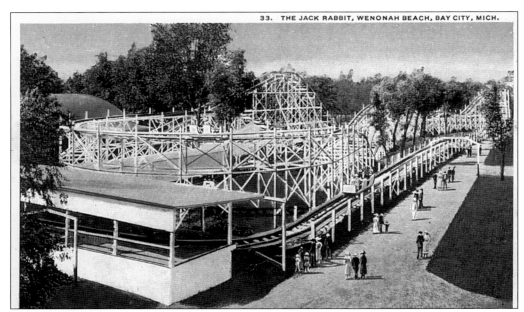

THE JACK RABBIT. This was not a long ride, but, oh my, did it go. As you went up and down you could feel the wooden structure shaking. James R. Watson describes the ride, "And then with a roar, the car plunged down the hill's backside, shaking the ground. Screams followed after the passengers caught their breath…as they whizzed 'round the curve, past the lightning rods, riders could look out over the Bay." What a ride!

CASINO AT WENONA BEACH PARK. Starting in 1935, Harry Jarkey was master of ceremonies at the Casino, a role he played for 25 years. (I remember my parents coming home and talking excitedly about Harry.) He was a stand-up comedian, a musician, and an introducer of talent. The Casino name lives on in memory because the mobile home park that is now located on the site of Wenona Beach has streets named North Casino Beach and South Casino.

Nine
MORE REAL PHOTOS

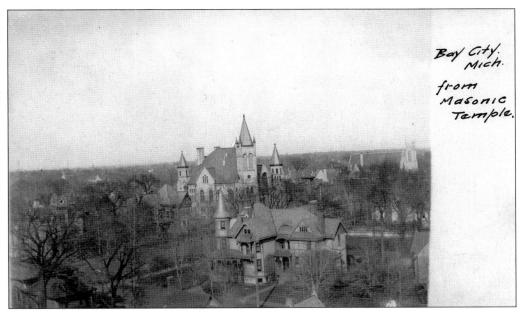

BAY CITY FROM MASONIC TEMPLE. In the distance, the First Presbyterian Church on Center Avenue can be seen and in the foreground is the home of businessman, Charles C. Whitney, built in 1885. The ten-room Whitney home was located five blocks east of the Presbyterian Church at 1315 Center. Whitney was druggist first, a partner and then sole owner of a cracker and biscuit company, and a banker. (Courtesy of Tom Sullivan.)

STATE FISH HATCHERY. A century ago, the Saginaw Bay was famous for the quality and quantity of fish it produced each year. But, over-fishing, pollution, and sea lamprey have taken their toll. The State Fish Hatchery helped overcome the first problem by hatching pickerel, perch, and herring, and in 1927 had great success. There was a time when fishermen lined the banks of the Saginaw River and covered the ice with shanties in the winter.

WATERWORKS, BAY CITY STATE PARK. Bay City's first waterworks system was for fire protection, not drinking water. After using smaller systems, this water pumping and filtration plant was approved by voters in 1920 and completed in 1925. Initially, water was taken two-thirds of a mile, but eventually a three and one-half mile line replaced it. This plant has been idle for many years awaiting a development project.

BAY COUNTY INFIRMARY. While private charitable groups like churches, lodges, and benevolent organizations provided most early social services, the county did establish the Bay County Infirmary two miles east of Essexville on the north side of Woodside Avenue. It was directed by the Bay County Social Welfare Board and included not only an infirmary, but also a convalescing hospital.

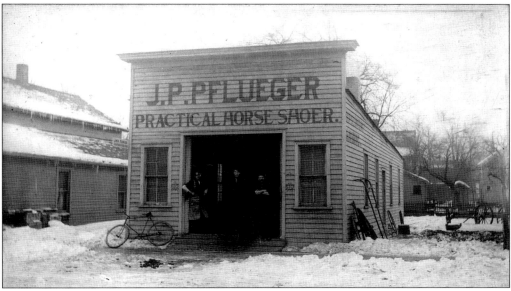

J.P. PFLUEGER, PRACTICAL HORSE SHOER. John P. Pflueger is listed in the 1916 Polk City Directory as having his horseshoe shop at 610 Third Street and living a mile further north on the same street. From the picture, it looks like in addition to horse shoeing, John repaired all types of metal implements. One wonders if he rode the bike to work or if it belonged to one of his assistants. (Courtesy of Barb and Pete Eichhorn.)

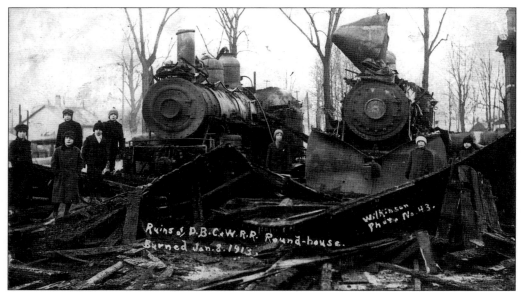

RUINS OF D.B.C.W.R.R. ROUND HOUSE. The Detroit, Bay City and Western Round House was located on the corner of Sherman and North Streets. You can just see the edge of Sherman School on the right side of the picture. The round house and locomotives were totally destroyed in the January 8, 1913 early morning fire. (Courtesy of Barb and Pete Eichhorn.)

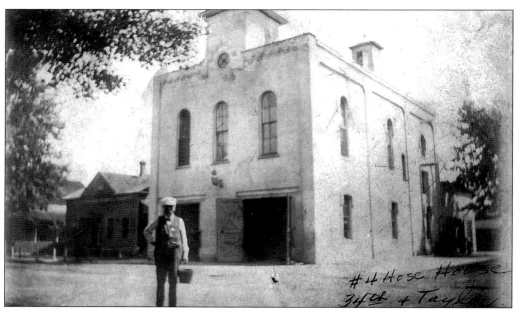

#4 HOSE HOUSE, 34TH AND TAYLOR. Some areas of the city have few postcards or none that have survived. Columbus Avenue and the Banks neighborhood are two such areas. The South End is another area with few postcards, although this rare view of the #4 Hose House is an excellent one. Standing in the foreground is likely Captain John Watson, who in 1917, was supported by Lt. Harry Richardson and Firemen Wallie Teale and Eugene Kellog. (Courtesy of Barb and Pete Eichhorn.)

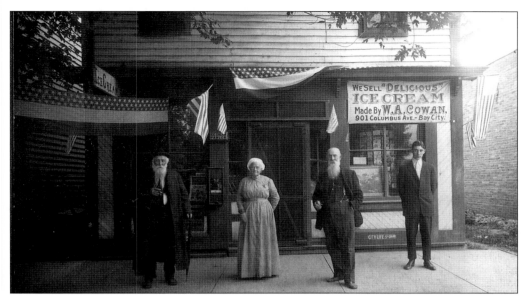

W.A. Cowan Ice Cream. Little is known about William Cowan's Ice Cream Store. This Columbus Avenue address was in the heart of Bay City's small Jewish community. From the picture, it is apparent that he made his own ice cream and was very patriotic since he was flying so many U.S. flags. This business was closed by 1916 because it is not listed in the 1916 Polk City Directory. (Courtesy of Barb and Pete Eichhorn.)

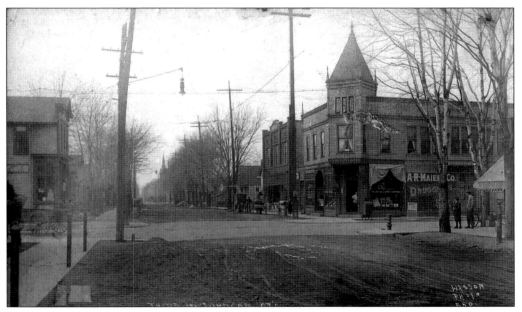

Third and Johnson Streets. One of the earliest business districts in Bay City that is still a viable business area today is the Johnson Street Business District. The corner of Third and Johnson has housed many different shops over the years. This particular card shows the Albert R. Maier Drugstore. Many Bay Citians remember when Goddyne's Sports was located to the right and Goddyne's Plumbing to the left of the corner property. (Courtesy of Tom Sullivan.)

WILLIAM HUBNER SALOON. Located very near the St. James Church on Columbus Avenue was William Hubner's Saloon that was also his home. The sign in his window said "Drink the Finest" beer. The Finest was one of the three Bay City beers that were brewed here. The others were made by Kolb and Phoenix Brewers. His window also advertises cigars. For many years, Bay City produced cigars with Hahn's Center Avenue being a local brand name. (Courtesy of Barb and Pete Eichhorn.)

PUBLIC SCHOOL, AUBURN, MICHIGAN. The Auburn Public School sat just west of the present day Auburn Elementary that is located at 301 Midland Road. It was a kindergarten through ninth grade school, originally with students who wanted further education; they transferred to Central or Midland and Handy in later years. It had its own elected school board and chose to join Bay City Public Schools when the state required kindergarten through twelfth grade districts in the late 1950s. It was built as a four-room school. (Today, Auburn is a newly renovated kindergarten through fifth grade school of which the author is proud to be the principal.) (Courtesy of Tom Sullivan.)

Ten
NEARLY
EVERYTHING ELSE

GREETINGS FROM BAY CITY. Every picture in this welcoming postcard is pictured elsewhere in this book. It gives you a sense of Bay City in 1909 emphasizing churches (St. James), hotels (Wenonah), the Saginaw River (steamer *State of New York*), fire protection (Fire House #3), lumbering (W.D. Young), government (City Hall), schools (High School), and transportation (Union Depot).

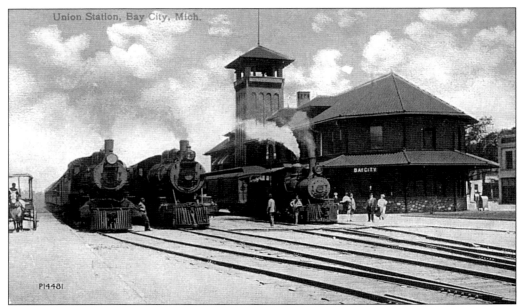

UNION STATION. Built in 1904, this was also known as the Pere Marquette Depot and in the 1950s and 1960s it was a Greyhound Bus Terminal. It is the last remaining passenger train station standing in town and efforts are being made to preserve the building, which is on the National Historic Register. On the far right is the office of the Delpheon Phonograph Company in business making phonographs whose trademark was "The Incomparable" from 1915 to 1922.

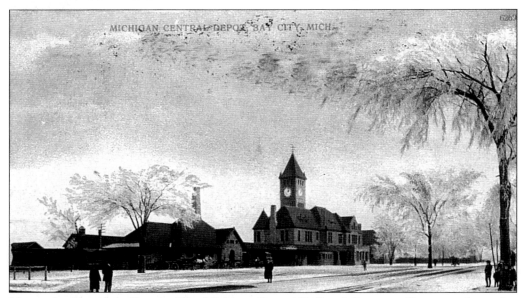

MICHIGAN CENTRAL DEPOT. The Michigan Central Railroad Company Depot was located at the foot of Jackson Street and First Street. I remember being carried on my father's shoulders in 1952 to hear Presidential candidate Dwight Eisenhower make a whistle-stop speech from a train. It was also a place from which we took train excursions to watch Detroit Tiger baseball games.

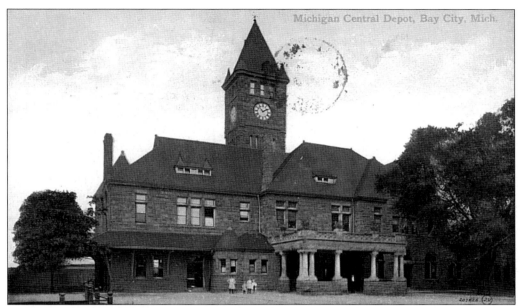

MICHIGAN CENTRAL DEPOT (CLOSE-UP). A close-up view of the Michigan Central Depot shows the clock tower and the gracefully columned entryway. Built in 1887, it was constructed of red sandstone and was in use until 1958. It was razed in 1964 after several fires. All that remains today is the Baggage Building that faces First Street just east of Madison.

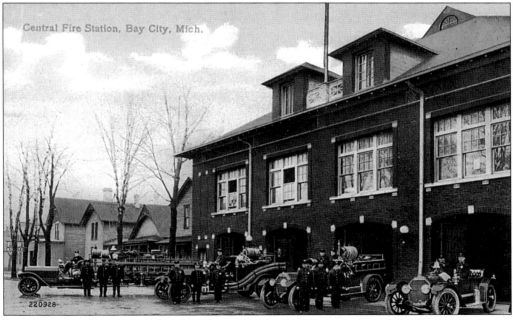

CENTRAL FIRE STATION. When Bay City wanted to build a new Central Fire Station on Center and Lincoln, many local people were upset because The Fire Department Headquarters had been located on 502 Adams on the corner of McKinley for so many years. This postcard shows Hook and Ladder Truck Co. No. 1, Motor Truck Co. No. 1 and 2, and the chief in his car.

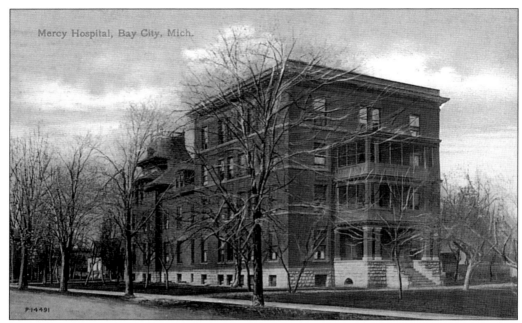

MERCY HOSPITAL. Formed from the old Nathan Bradley home in 1899, Mercy Hospital was staffed for many years by the Sisters of Mercy. Located on the corner of 15th Street and Howard, Mercy was Bay City's first hospital. It lasted into the 1970s, when Bay Medical was formed, merging General, Mercy, and Samaritan hospitals. You can see the Bradley home section to the rear of the building.

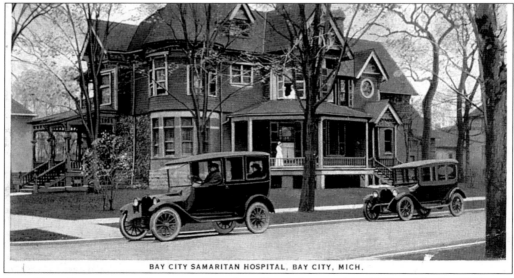

BAY CITY SAMARITAN HOSPITAL. Samaritan Hospital opened in 1918 and in the 1970s was converted to a drug abuse treatment center. The message on the back of this 1925 card says, "Dear Bill, Sure am enjoying myself in this wild town. Saginaw is dull compared to the 'big town' of Bay City." Signed, "A Pal." Makes you wonder why "A Pal" chose a hospital postcard for that message.

MASONIC TEMPLE. Standing on Madison one block south of Center, the Masonic Temple looks much today as it did in 1893, minus the domes on the roof and the ornamental tiles along the roofline. A fire in 1903 damaged the building and destroyed these sections. Rebuilding restored the interior but left the room without domes and tiles. The inside has offices, parlors, a large meeting room, lounges, and a banquet room.

HOME OF NORTHEASTERN SCHOOL OF COMMERCE. Right across the street from the Masonic Temple, the Bay City Business College had once been located behind the Washington Theater on Washington Avenue. The business college moved to the Ridotto Building where it stayed until the fire in 1940 that also caused the college to lose most of their records. It moved to this site around the corner in 1941 and changed its name to Northeastern School of Commerce.

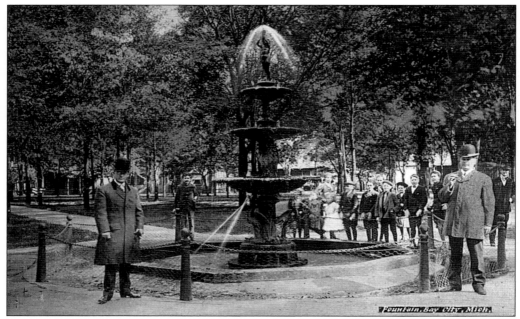

FOUNTAIN (BIRNEY PARK). James Birney ran for president of the United States in 1840 and 1844 on the anti-slavery Liberty Party. Although he was unsuccessful, he was an honored citizen and has a street and park named in his memory. Birney Park is located just south of the Masonic Temple on Madison Avenue. While the fountain has been gone a long time, the park and memories of James Birney remain.

CARROLL PARK. Bay City pioneer, Charles Fitzhugh, donated the land for Carroll Park. Today, it is home to a duck pond, tennis courts, ball diamond, playground equipment, and picnic tables. This postcard shows it to be a wooded, grassy place really removed from houses. It is located about a mile east of the downtown area and north of Center Avenue.

BAY CITY'S LARGEST AND MOST UP-TO-DATE GARAGE 1912
FIFTH AND MADISON BAY CITY, MICHIGAN

MOHR AUTO CO. Mohr Brothers was one of the most popular hardware stores in town. Another brother, William C., owned Mohr Auto Company in 1912, located at Fifth and Madison. The 1913 Polk Directory advertises their products this way: "Agents for Hudson and Reo Cars and Federal Trucks, General Repairing, Storing, Accessories, etc." There was no entry for William or Mohr Auto in the 1916 Polk Directory. (Courtesy of Barb and Pete Eichhorn.)

CLEMENTS AIRPORT AS SEEN FROM HIGHWAY U. S. 23, BAY CITY, MICH.

CLEMENTS AIRPORT AS SEEN FROM HIGHWAY U.S. 23. William Clements was the owner of the Industrial Works. His son, James Clements, died overseas while serving in the Navy during World War I. William Clements and James Davidson donated the site located about a mile south of the city. Henry Dora, who had flown with the Wright Brothers in 1913, was construction supervisor and the first manager of the airport that opened in 1928.

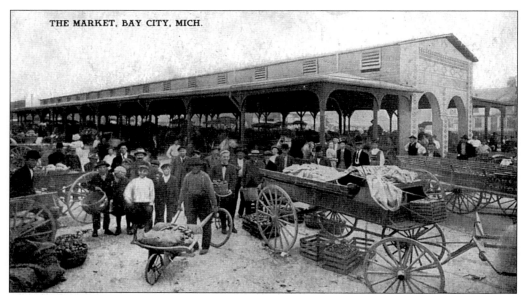

THE MARKET, BAY CITY, MICH.

THE MARKET. About a mile north of the present Market, this one was located between Washington and Saginaw Streets on the south side of Second Street about 1908. It was at this location because of the many wholesale produce stores along Saginaw and Third Streets at the turn of the last century. Bay County took over the Market in 1925 and moved to its present location.

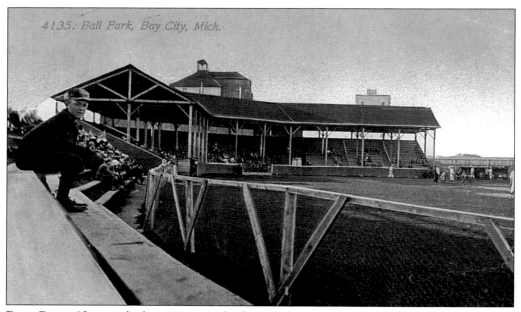

4135. Ball Park, Bay City, Mich.

BALL PARK. If you rode the streetcar to the far end of Center Avenue in 1909 or later, you were at the Clarkson Park. Baseball arrived in Bay City in 1882 with a team called the Bay City Independents. It was named after an 1880s player, John Clarkson, who played with Chicago and the Boston Nationals. A later team, The Bay City Wolves, starred Ki Ki Cuyler, who went on to play for the Pirates and the Cubs.

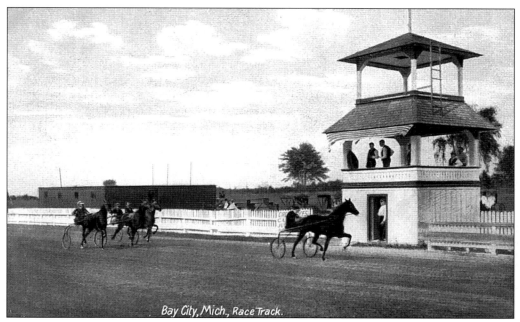

Bay City, Mich., Race Track.

RACETRACK. Horse racing was permitted between Park Avenue and Lincoln by city council order in 1897. The police had to patrol for safety during those two hours as long as it didn't interfere with fire safety. The racetrack in this postcard was probably on the site of the present fairgrounds on the northeast side of the city.

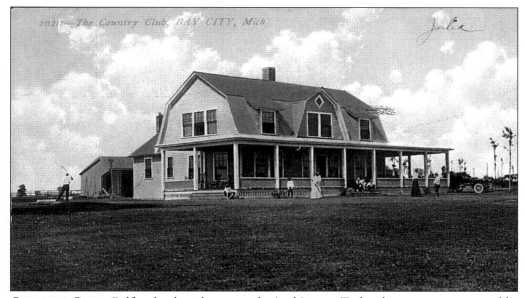

2021—The Country Club, BAY CITY, Mich.

COUNTRY CLUB. Golfing has long been popular in this area. Today there are numerous public courses and the Country Club is a private course just southwest of Salzburg. This 1907 picture of the Country Club shows its location on the southeast corner of Barclay and Fisher Avenues. That version of the Country Club was at that location until the present club was built in the late 1970s. The site has rolling hills and some of the original land is now designated as wetlands.

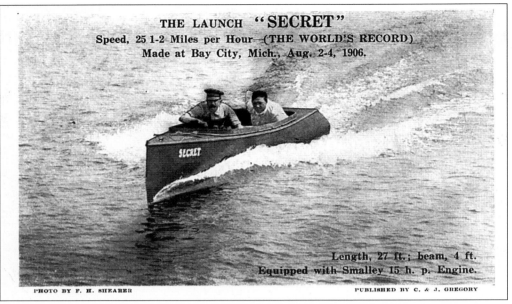

THE LAUNCH "SECRET." Bay City was famous for the boats made here, both large and small. In addition to the big companies like Davidson, Wheeler, and Defoe, there were smaller ones like the Bay City Boat Company which turned out wooden pleasure craft and racing boats. With today's speeds, it is hard to imagine 25 1/2 miles per hour as a world record, but in 1906 it must have seemed terribly fast. The Smalley engine was made here, too.

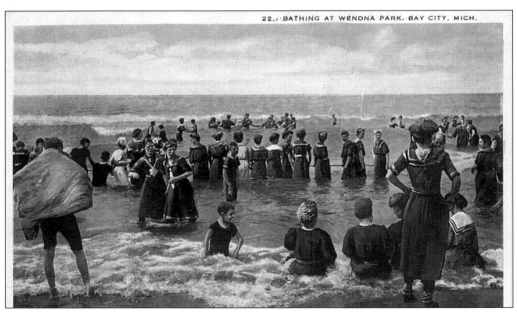

BATHING AT WENONA PARK. Check out the 1920 bathing suits. It appears that people went swimming nearly fully clothed. Back in those days, there was a wide sandy beach and great swimming. Many people combined their amusement park activities with time on the beach. Finding clean water at a public beach is much harder to do today.

OFFICE OF THE

Portsmouth & Bay City Wooden Ware Works,

MANUFACTURERS OF WOODEN WARE,

Common Pails, China Pails, **P** Dairy Pails, **A** Stable Pails, **I** Fire Pails, **L** Half Pails, **S** Tubs and KEELERS.

Foot of 34th Street, Corner of Water.

G. H. VanEtten, Pres't. }
A. H. VanEtten, Sec'y. }

Bay City, Mich. *Sept 1st,* 187*4.*

I shall have the pleasure of calling upon you on or about the 6th inst., representing the above establishment.

Please reserve any orders you may have until my arrival, and oblige,

Yours, Very Respectfully,

J. F. Ewing.

OFFICE OF THE PORTSMOUTH AND BAY CITY WOODEN WARE WORKS. By far the oldest card in the book, this advertising postcard was mailed in 1874 offering the wares of the Portsmouth and Bay City Wooden Ware Works. Amazingly, according to the back of this card, the Bay City salesman (and company bookkeeper), James Ewing, was willing to call on a client in Lafayette, Indiana. Portsmouth eventually became the South End of Bay City.

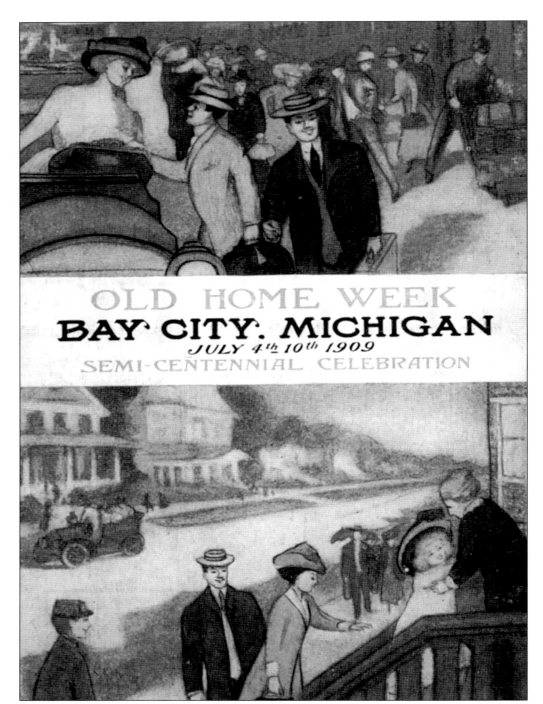

OLD HOME WEEK. Bay City was incorporated in 1859 and stayed a village until 1865. This postcard celebrates the 50th anniversary of the village's incorporation. Other similar celebrations have been the Bay County Centennial in 1957 and the centennial of Bay City in 1965, commemorating 100 years of being an official city.

Plenty of hugging here
in Bay City, Mich.

PLENTY OF HUGGING HERE IN BAY CITY, MICHIGAN. Genre cards like this were made for many cities with the local city names inserted. Other such Bay City cards say things like "I'm seeing the Sights in Bay City, Michigan but you should worry," and " I'm spending all my money in Bay City, Michigan but I'll get some more for you."

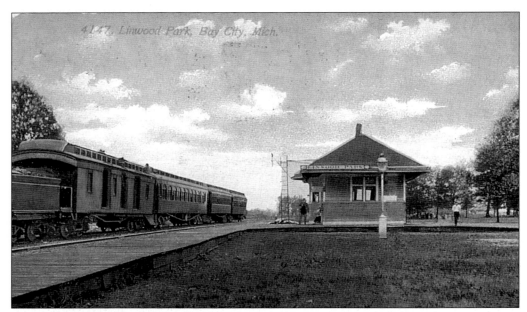

LINWOOD PARK. The recently published *Recipe for a Community* based on the *Myra Parsons Diaries* sheds much information on the northern Bay County community of Linwood. Linwood was built around the Parsons' farm and Myra was involved with every aspect of the community, from schools to farming to health care. Eleven miles north of Bay City, the Linwood Depot was a railroad station on the Detroit and Mackinaw Line. It was a popular tourist stop.

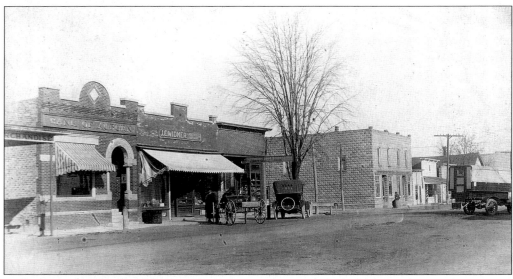

AUBURN, MICHIGAN (DOWNTOWN). The same Spencer Fisher who helped build Wenona Beach had a plank road built to Midland in 1875 and Fisherville still carries his name. The village of Auburn was founded in 1858, ten miles west of Bay City and just a few miles east of Fisherville. Marguerite Sullivan, 103, remembers having dinner at the Wenonah Hotel and riding out the plank road with her future husband. They eventually were married and owned the Auburn Grain Elevator and she later served on the board of the Auburn Bank.

VIEWS OF BAY CITY, MICHIGAN. As this book on Bay City postcards closes, a 1908 "Compliments of the *Bay City Tribune*, Bay City's Best Newspaper" card shows one last time the many things of which Bay City was proud. City Hall and the Masonic Temple remain, and as this book of postcards shows, wonderful memories remain, too, showing many fine buildings and activities of times long past.

SELECTED
BIBLIOGRAPHY

(ALL FROM THE AUTHOR'S COLLECTION WITH THE TWO EXCEPTIONS NOTED BY ASTERISK)

A History of the Bay City Fire Department, 1918.
Aladdin Homes. Various catalogues. 1912-1950.
Arndt, Leslie E. *Bay County Story.* 1982.
Bay City Public Schools Building Survey. 1955.
Bay City Times. Various issues.
Bay County Past and Present. 1918 and 1956.
Bloomfield, Ron and Drury, Pat. *Recipe for a Community based on the Myra Parson's Diarie*s. 2001.
Bloomfield, Ron and Kilar, Jeremy. *Bay City Logbook.* 1996.
Greenwood, John O. *Namesakes 1930–1955.* 1978.★
Gregory, C. and J., publishers. *Bay City and West Bay City Michigan. c.* 1900.
———. *Bay City Illustrated.* 1900.
History, Commercial Advantages and Future Prospects of Bay City Michigan. 1875.
Industrial Works Cranes Fiftieth Anniversary Edition. 1923.
Living Heritage: A Tour of Bay City's Fabulous Architecture From the Pages of the Bay City Times. 1998.
Mahar, Tom. *Sweet Energy: The Story of Monitor Sugar Company.* 2000.
Maillette, Dolores. *St. Joseph Church: 150 Years by Dolores.* 1999.★
National Cycle Catalogues. Various. 1895-1915.
Polk City Directories. Various.
School News of Bay City Union School District. 1923.
Souvenir of Bay City Dedicated to the Teachers of Michigan. 1910.
The Wenonah. 1908.
Watson, James R. *Wenona Beach.* 1988.
Wolicki, Dale. *Historic Architecture of Bay City Michigan.* 1998.
World Star Hosiery and Underwear Catalogues. Various.